JULIE MEHRETU

DRAWINGS AND MONOTYPES

DRAWINGS

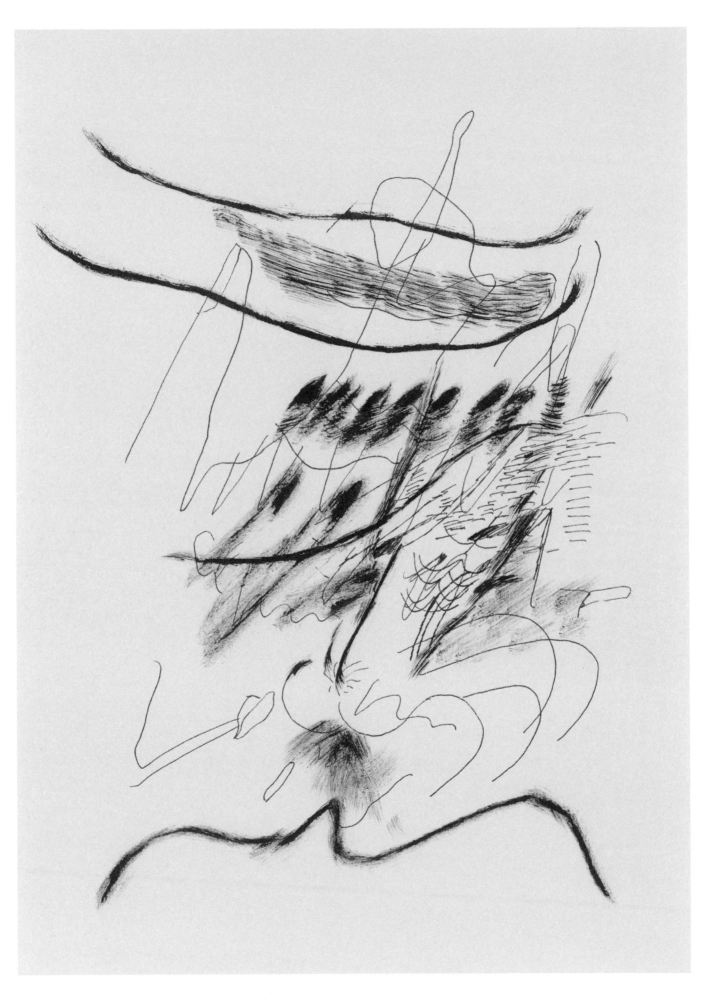

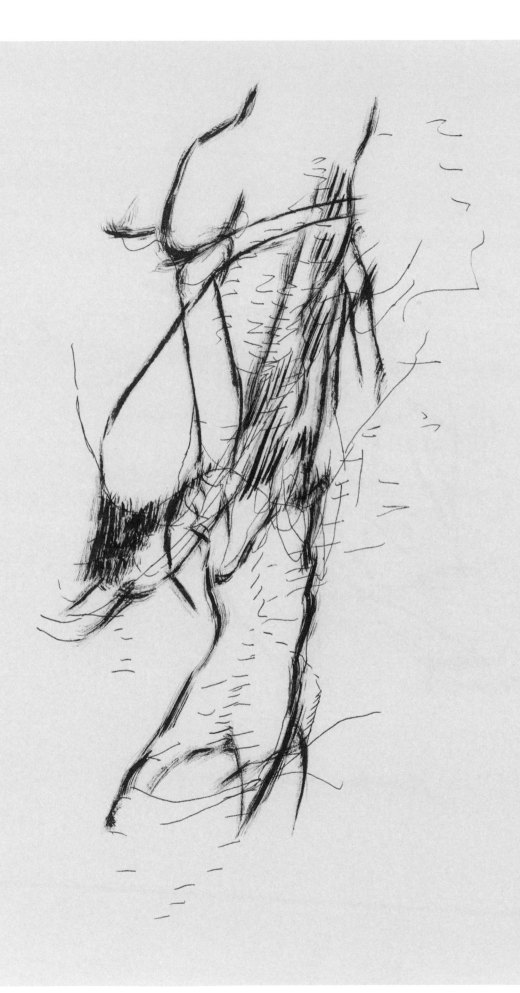

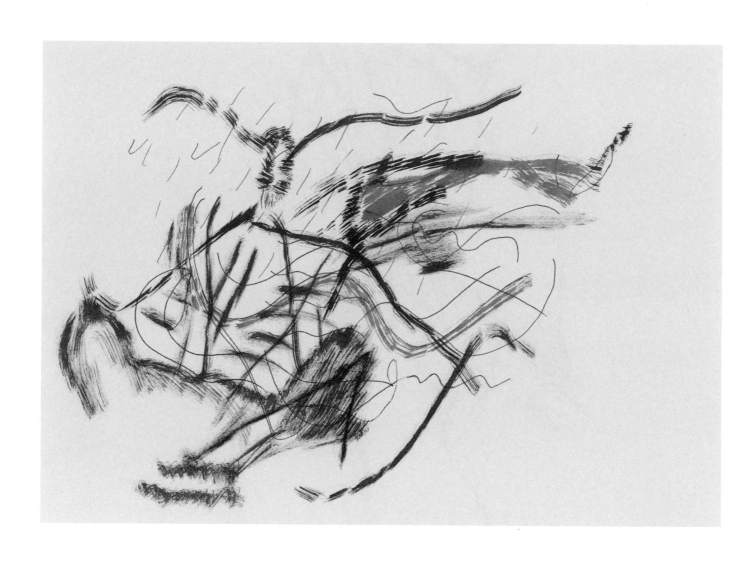

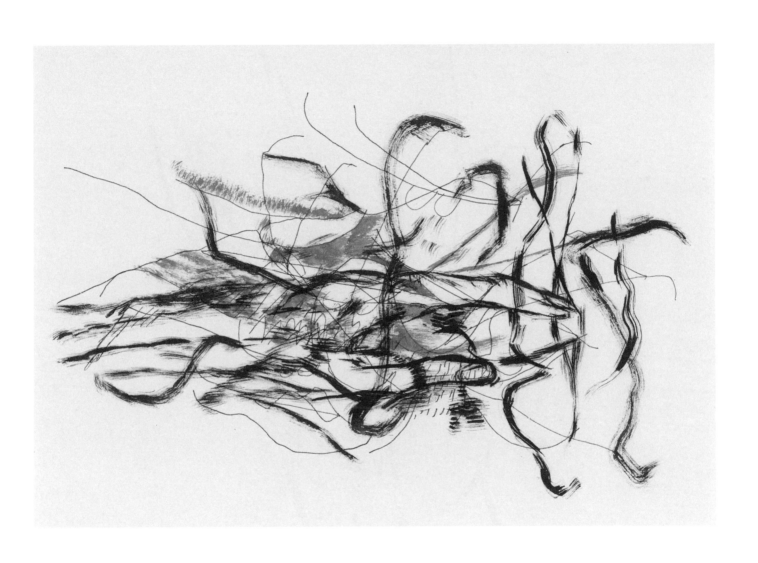

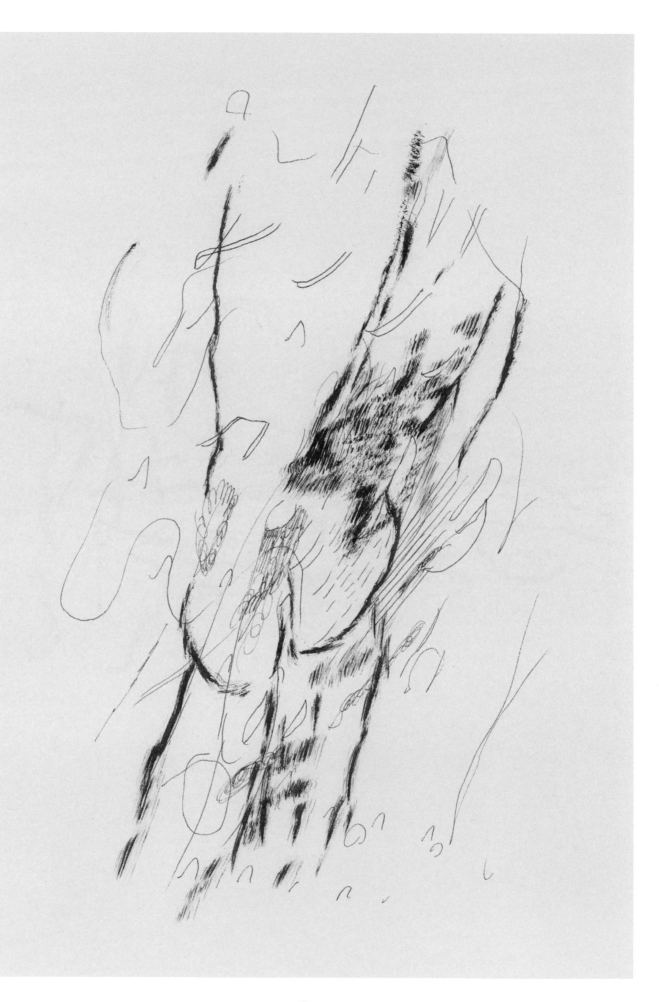

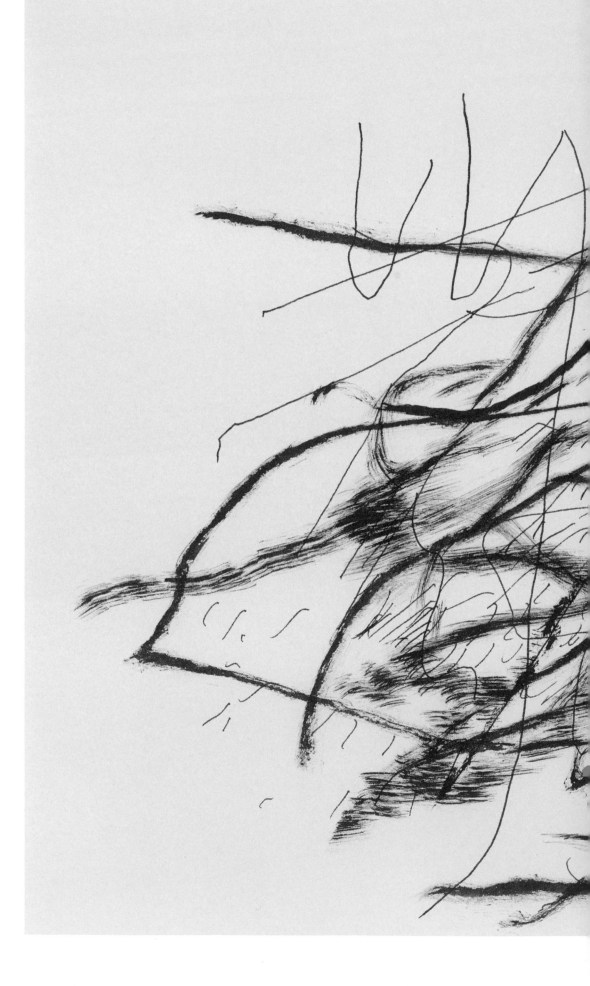

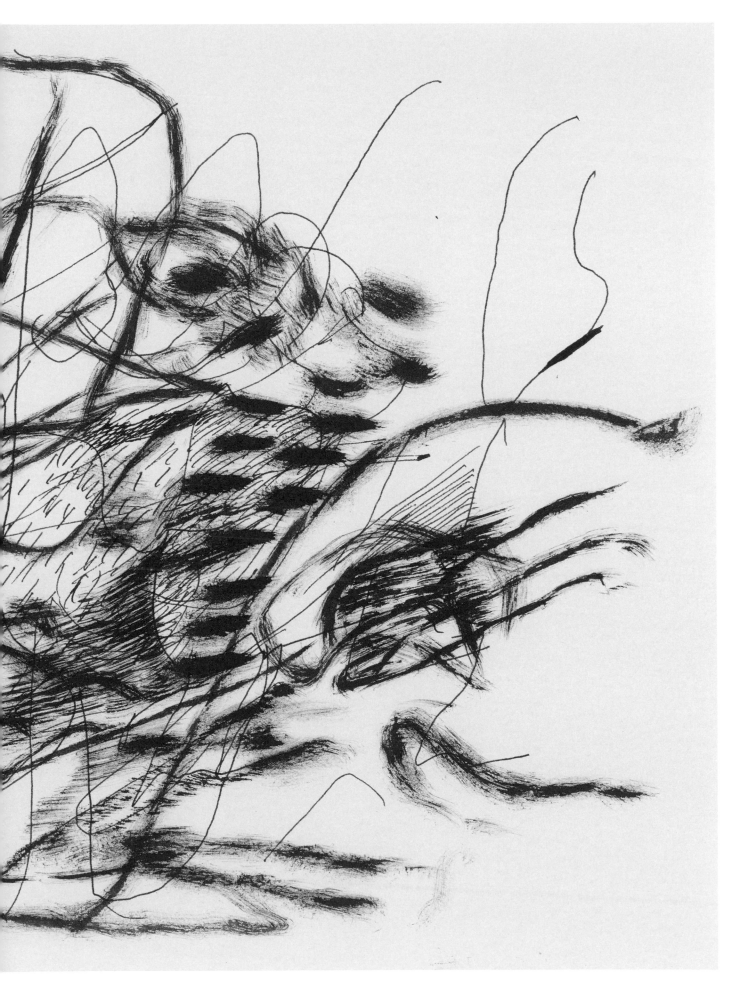

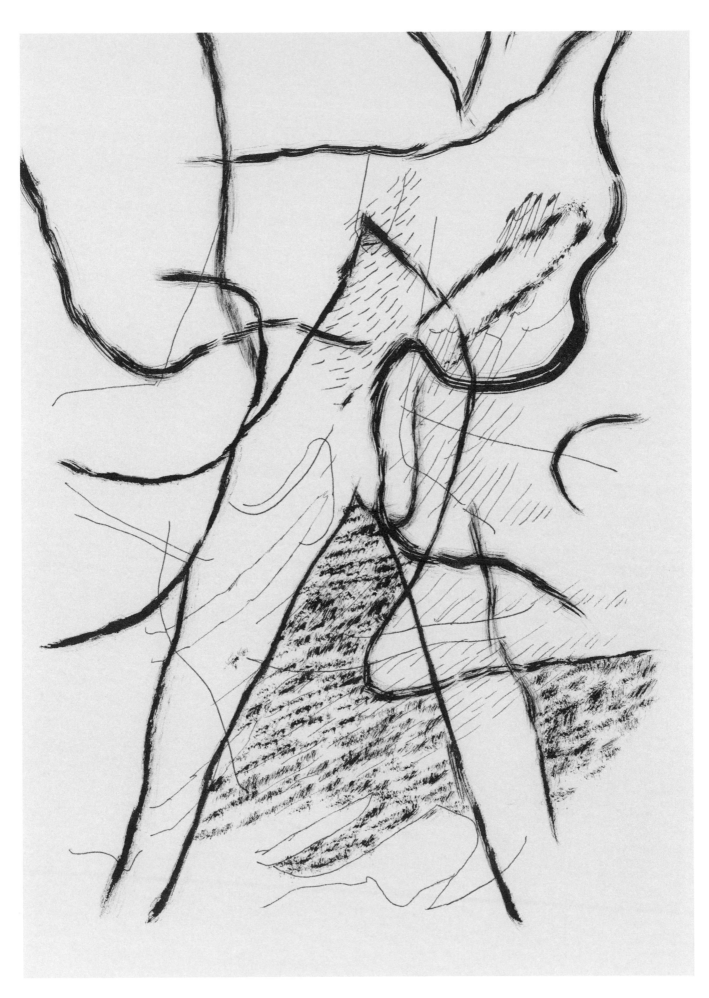

MONOTYPES

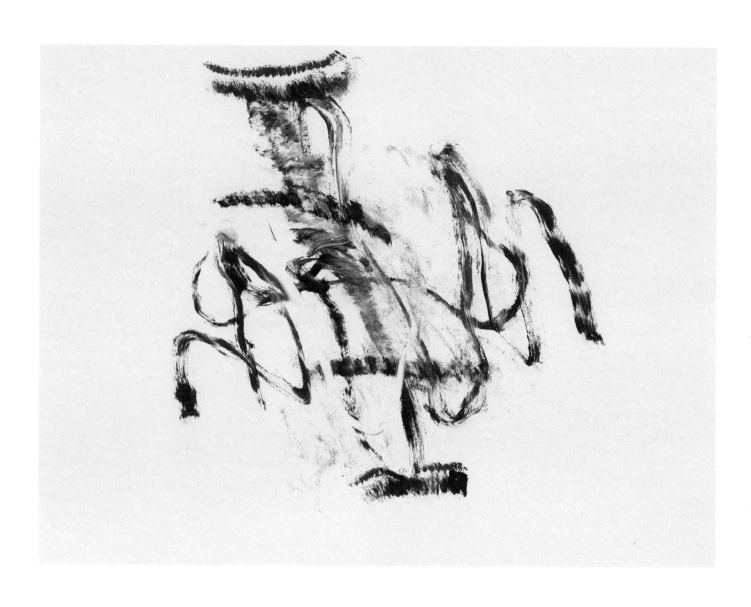

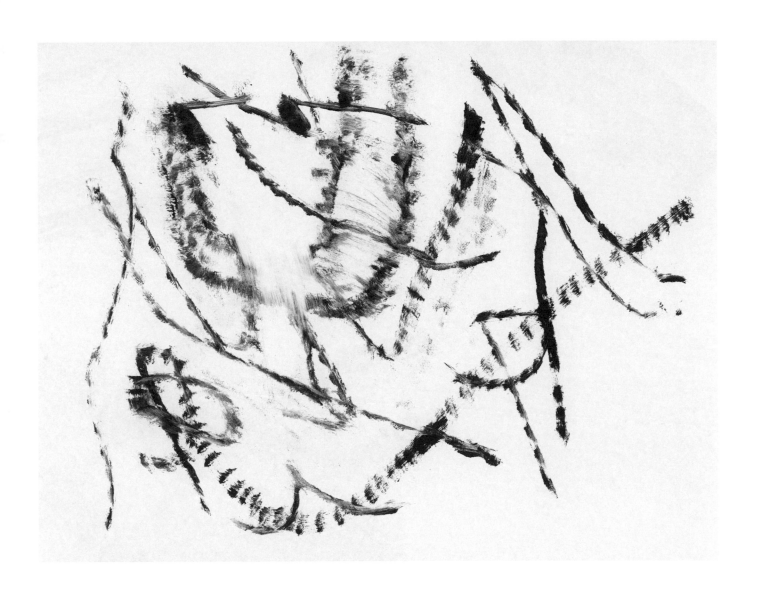

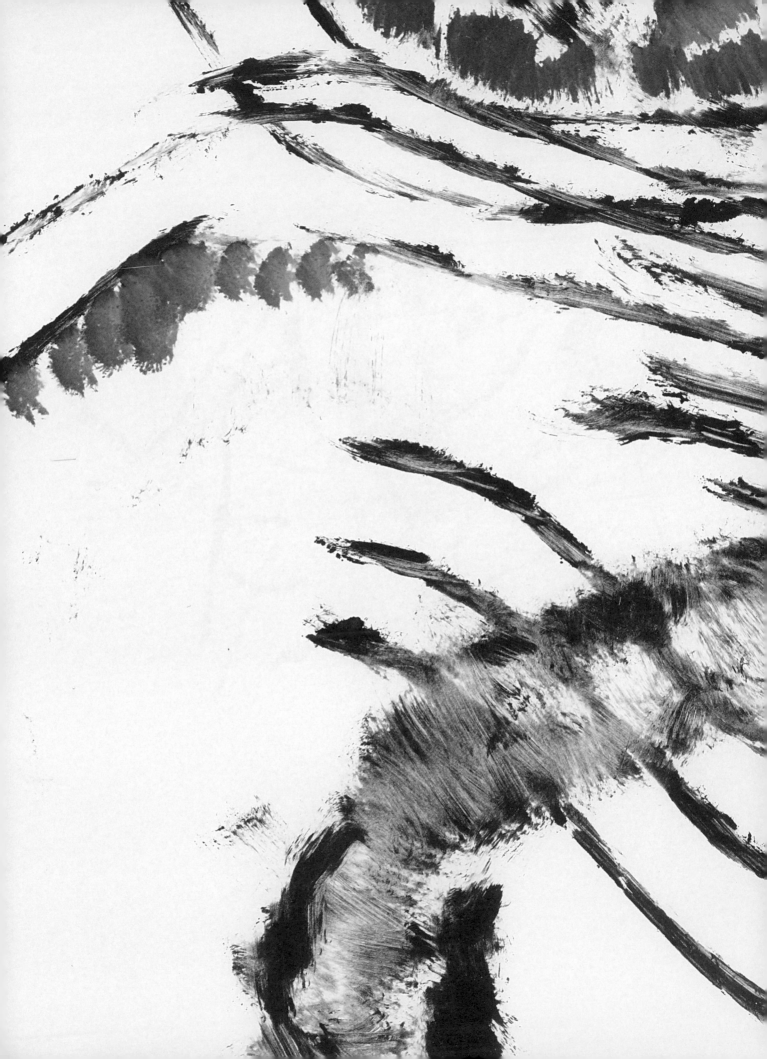

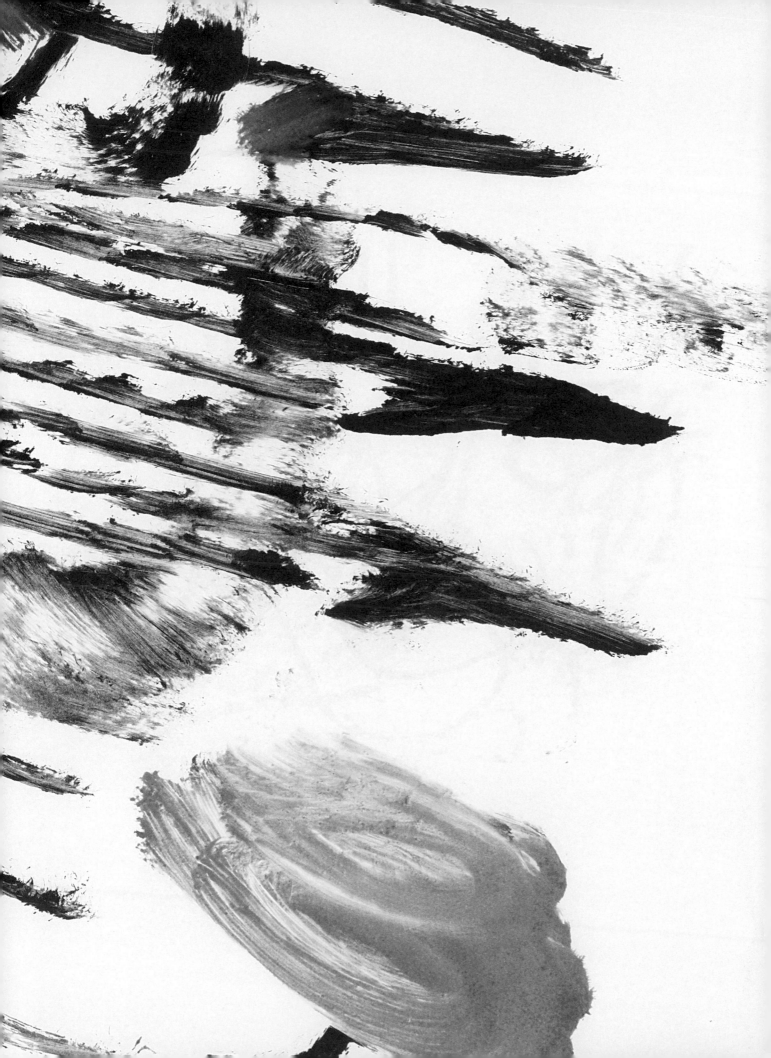

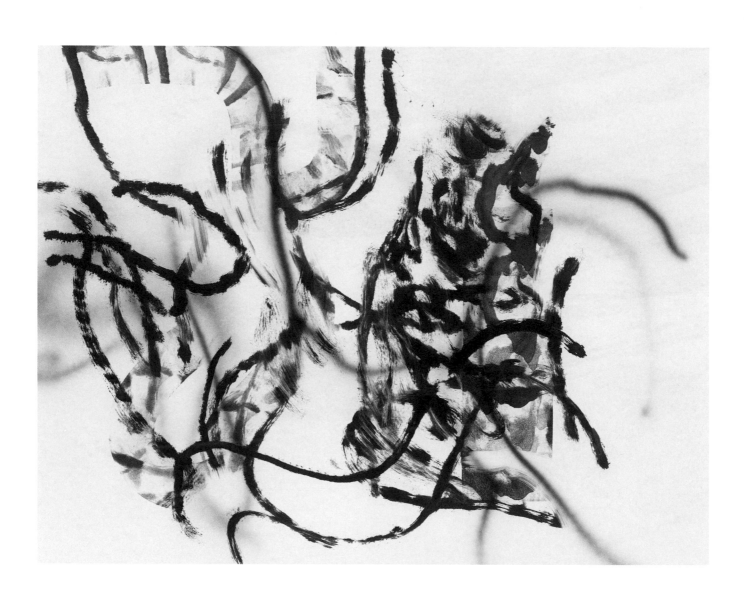

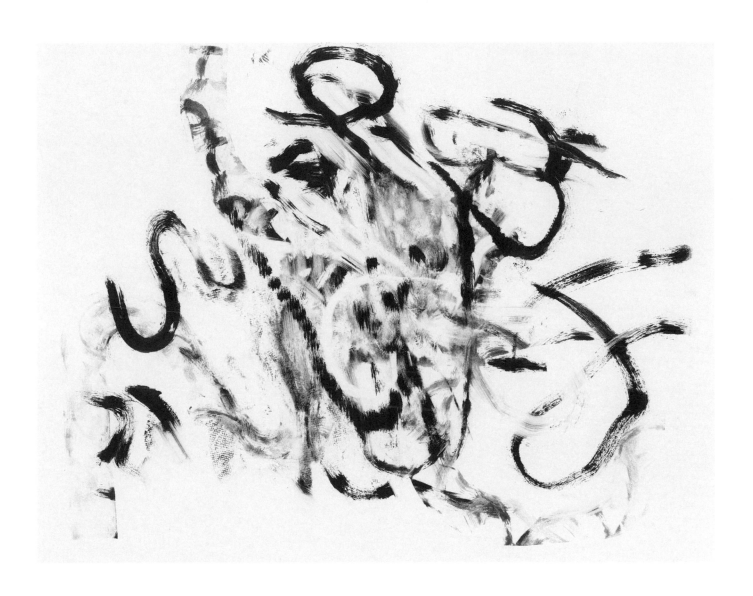

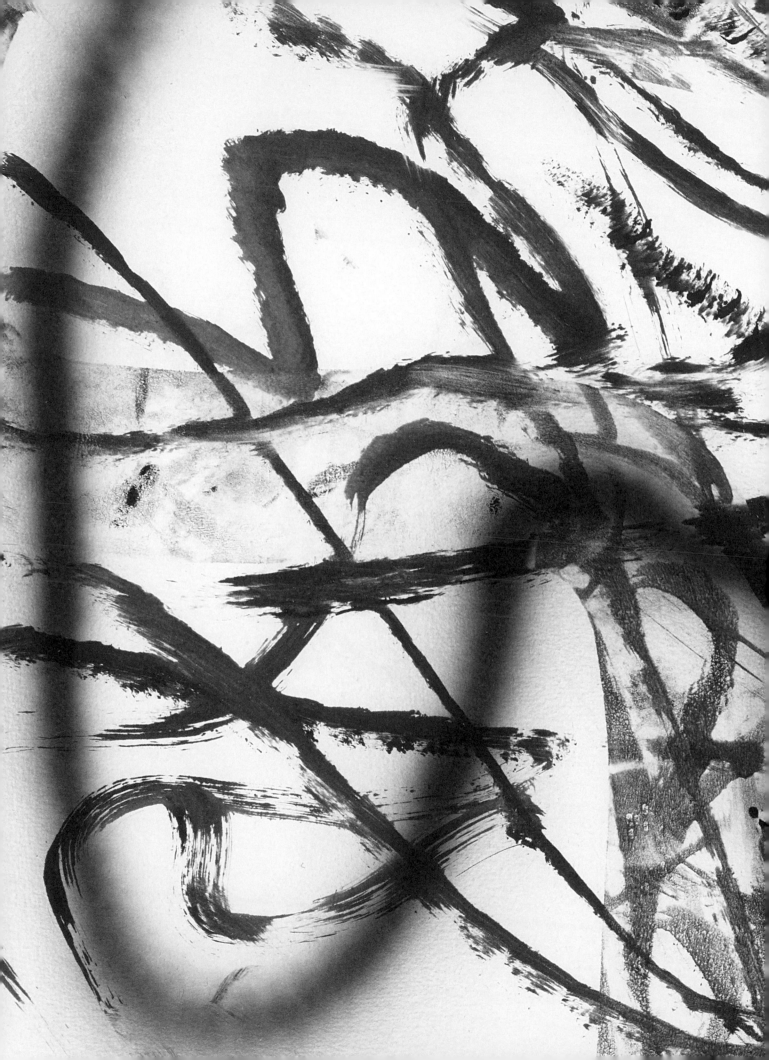

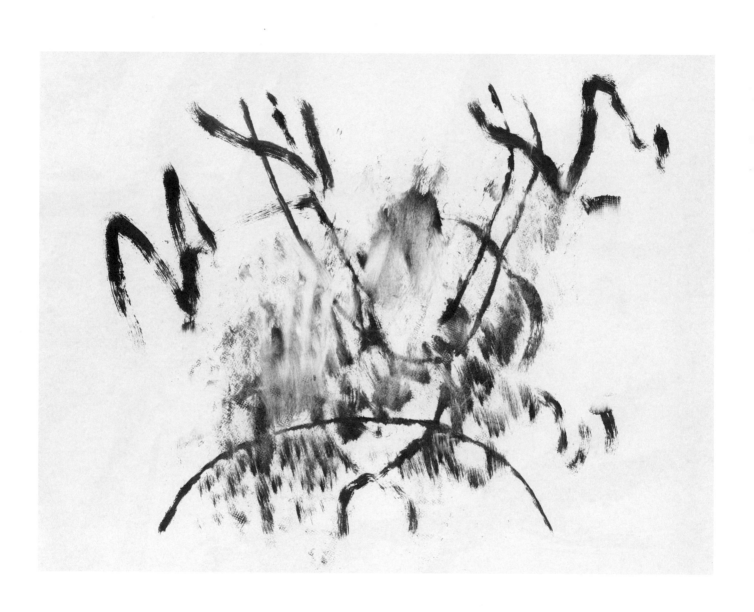

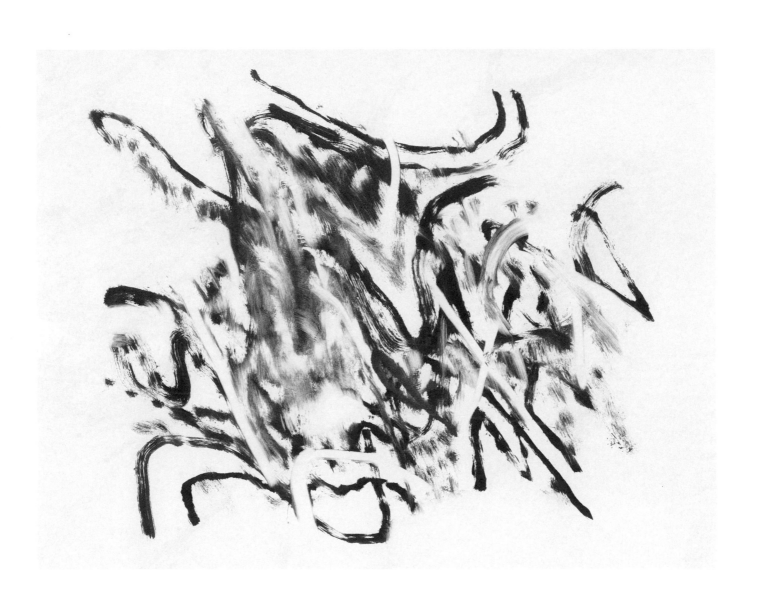

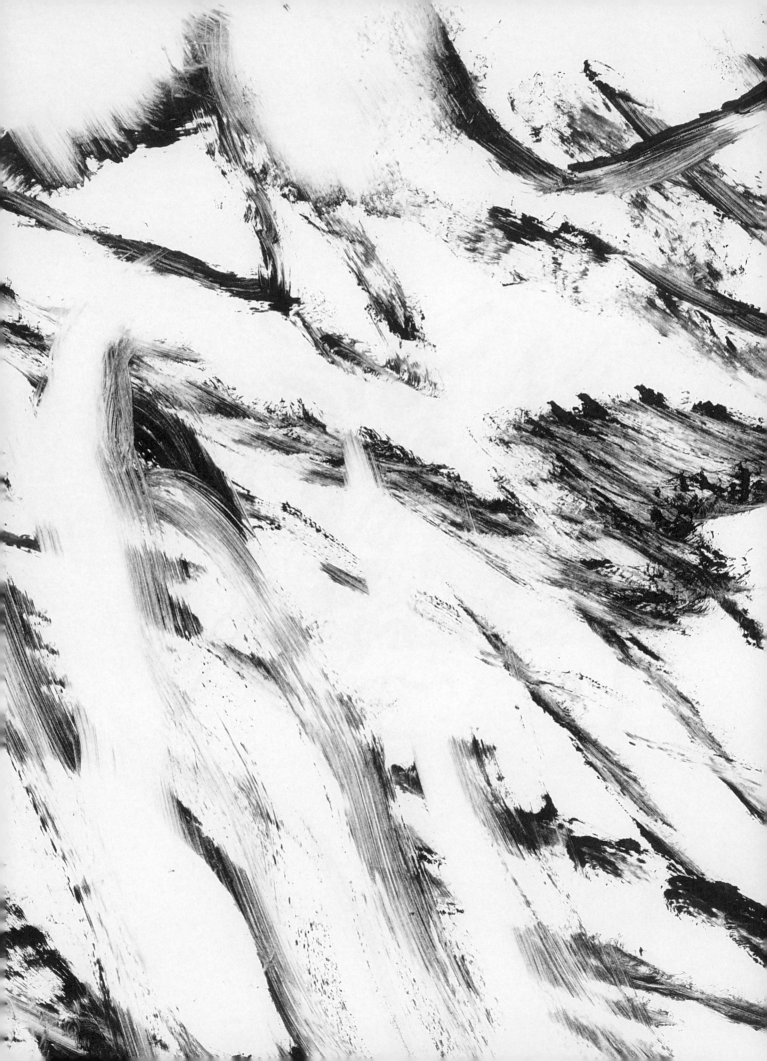

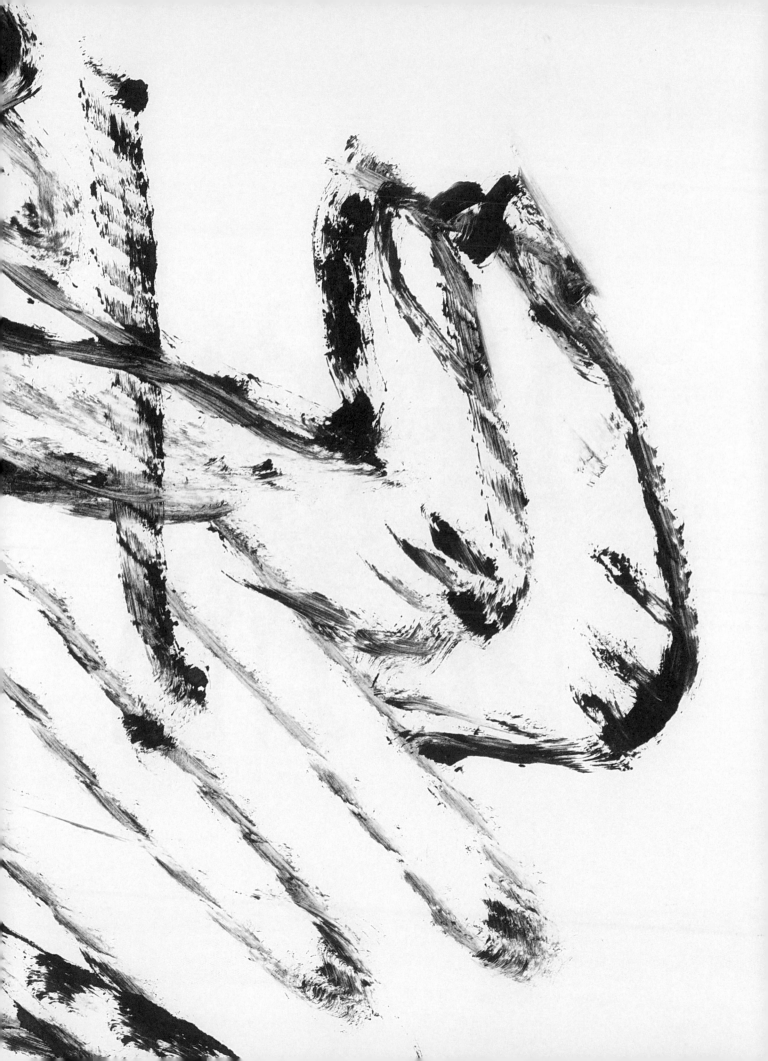

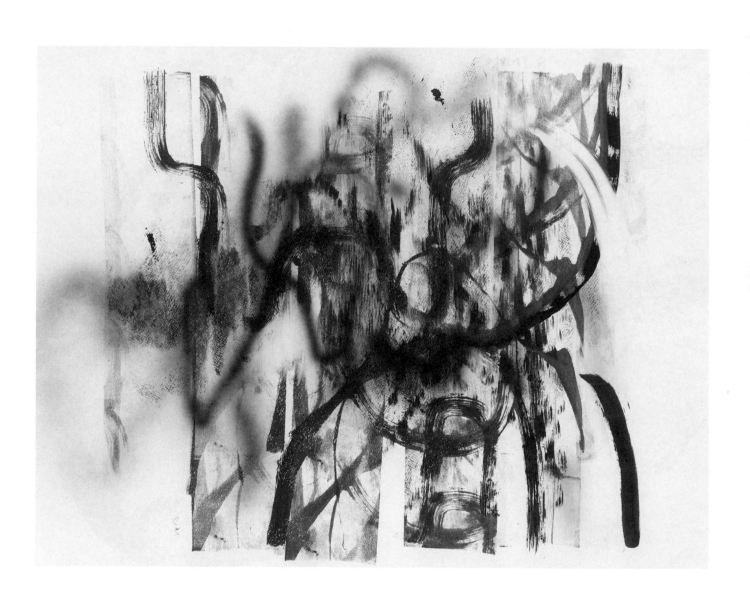

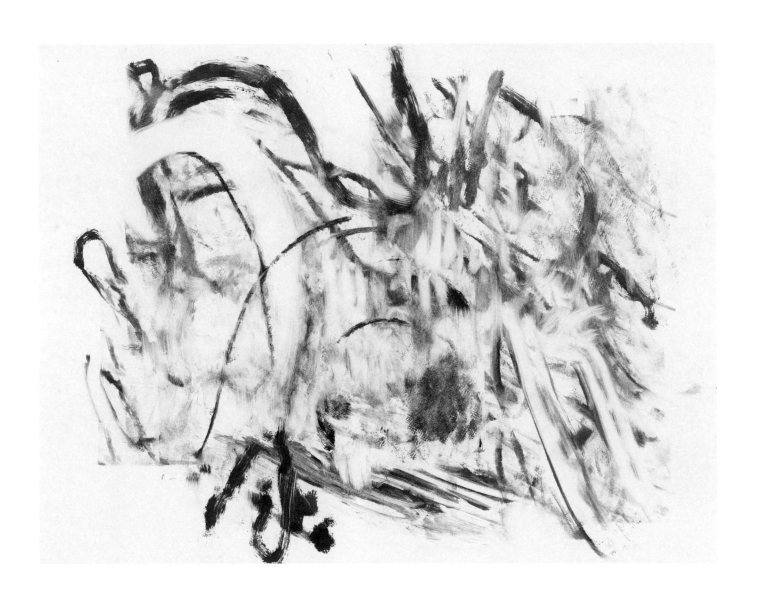

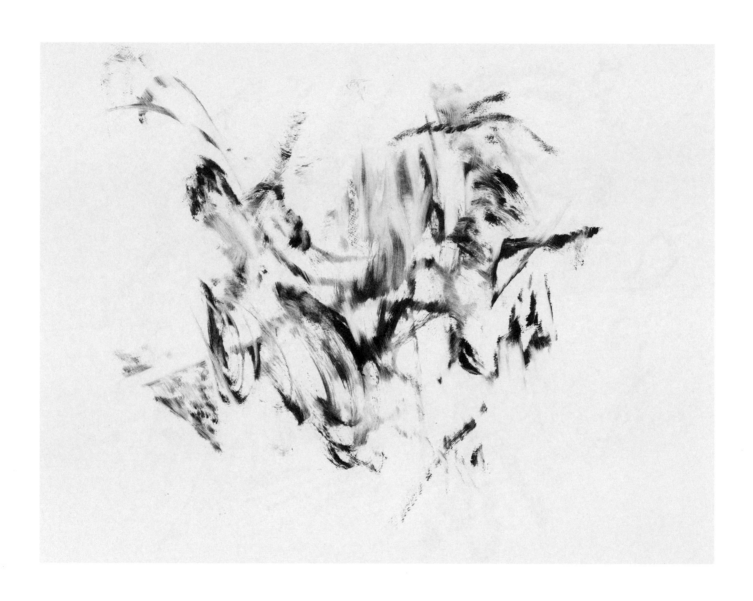

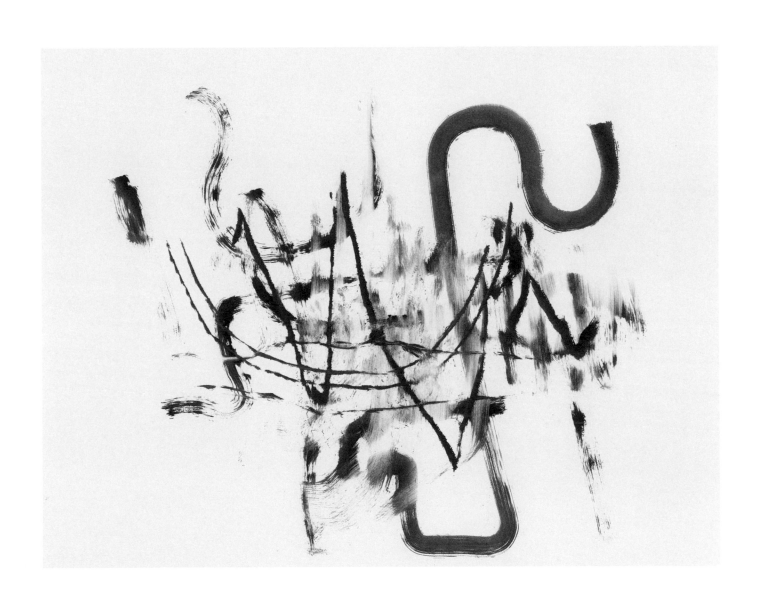

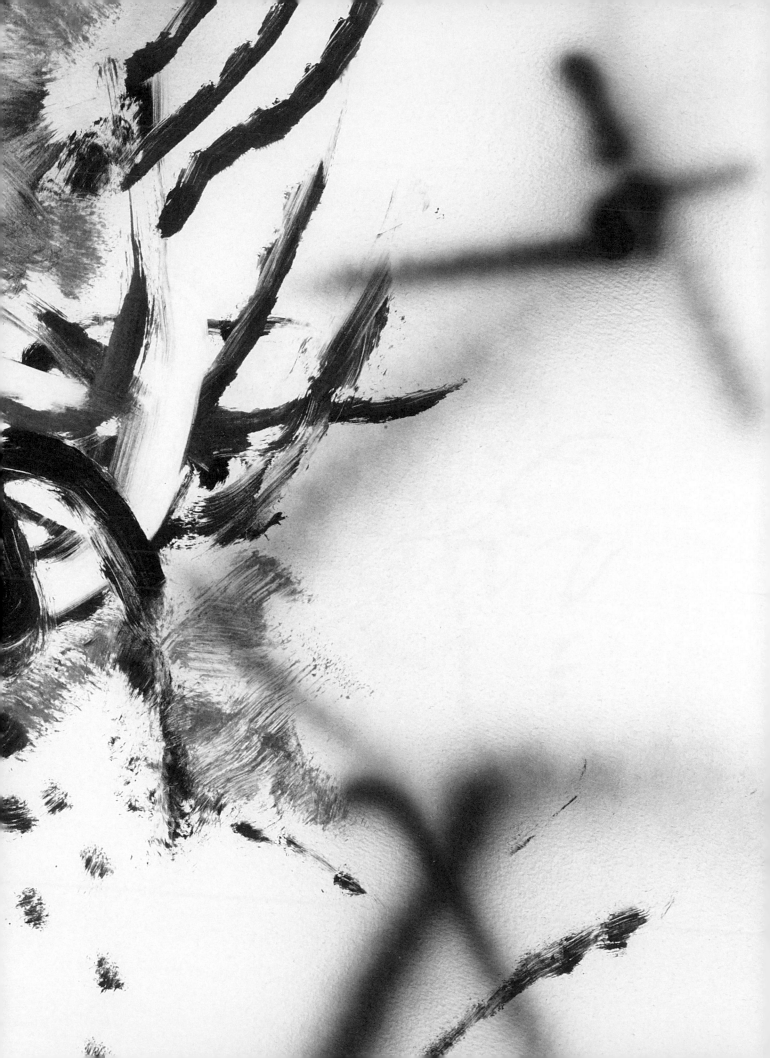

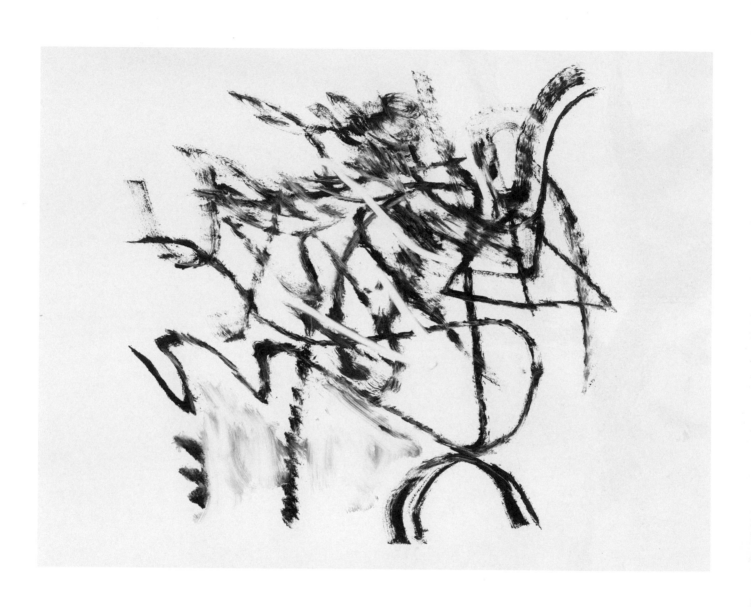

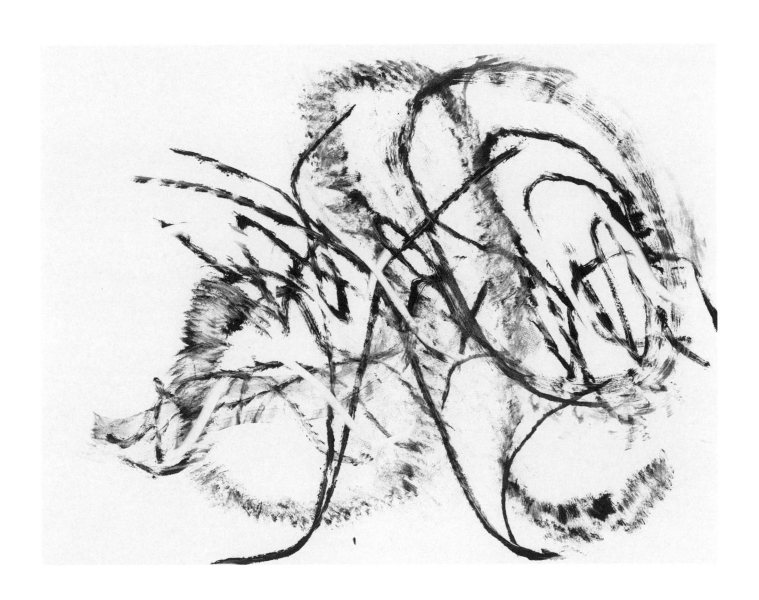

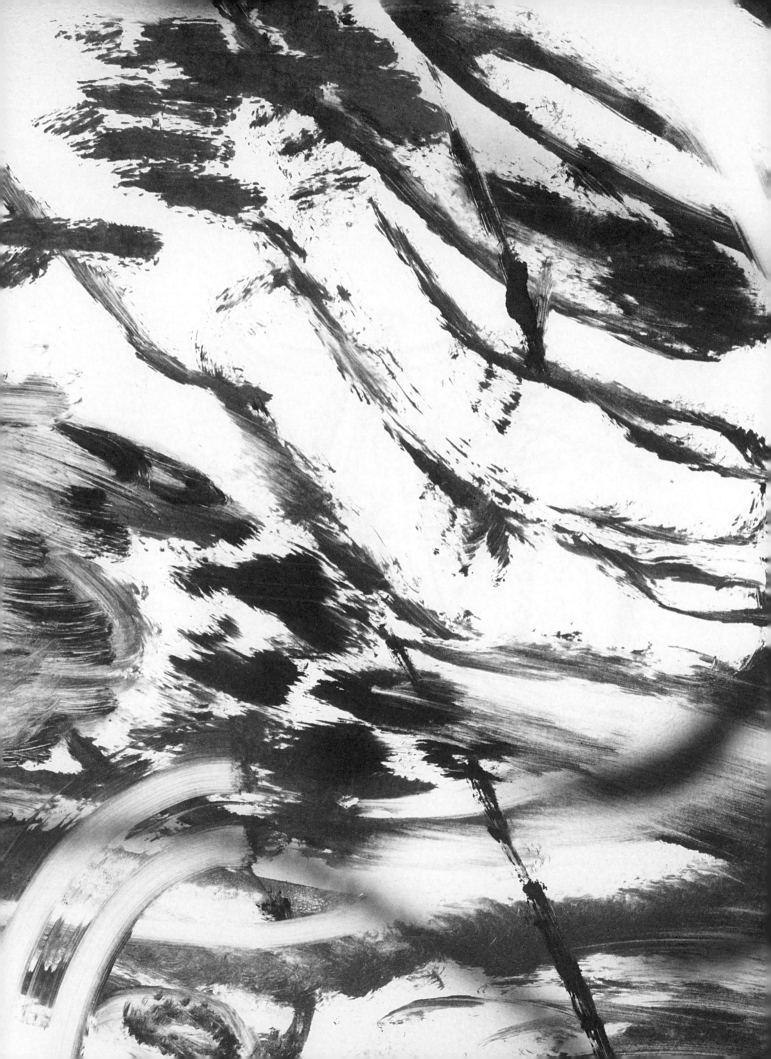

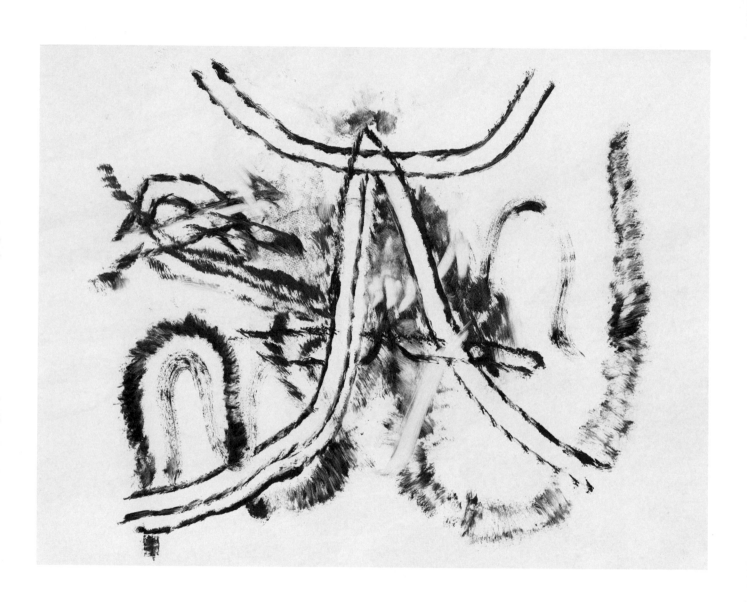

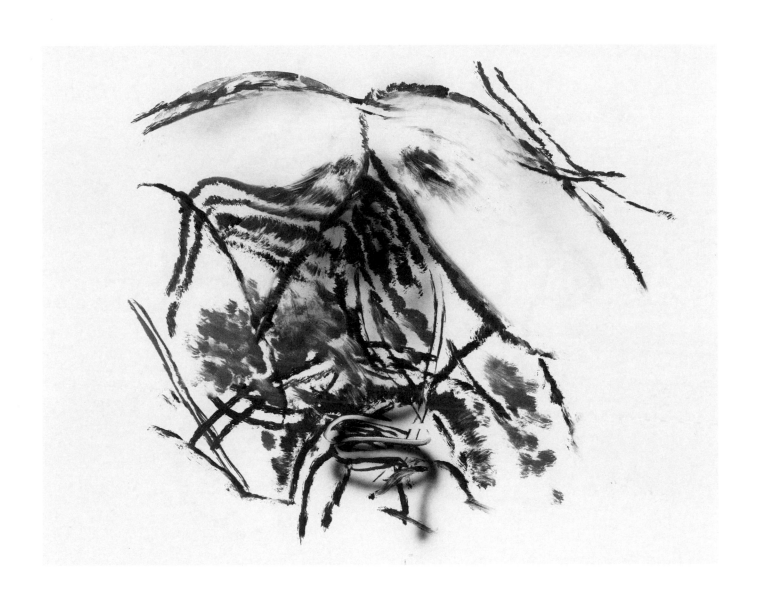

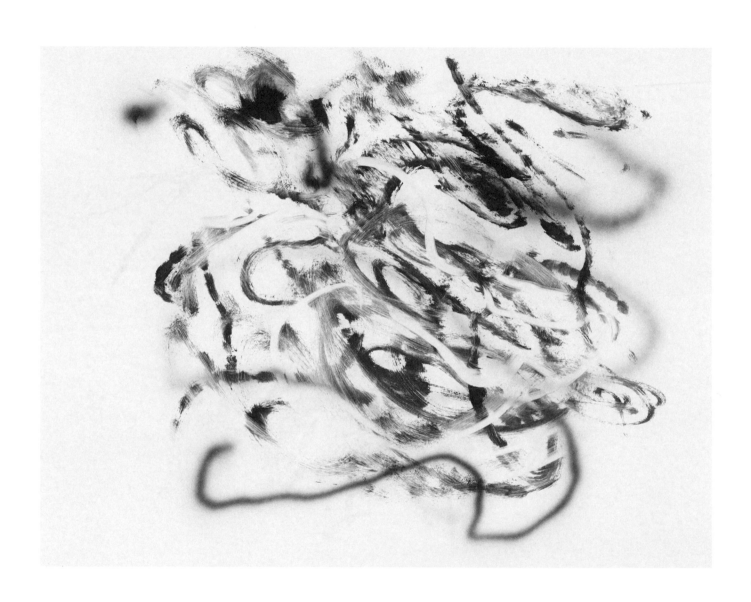

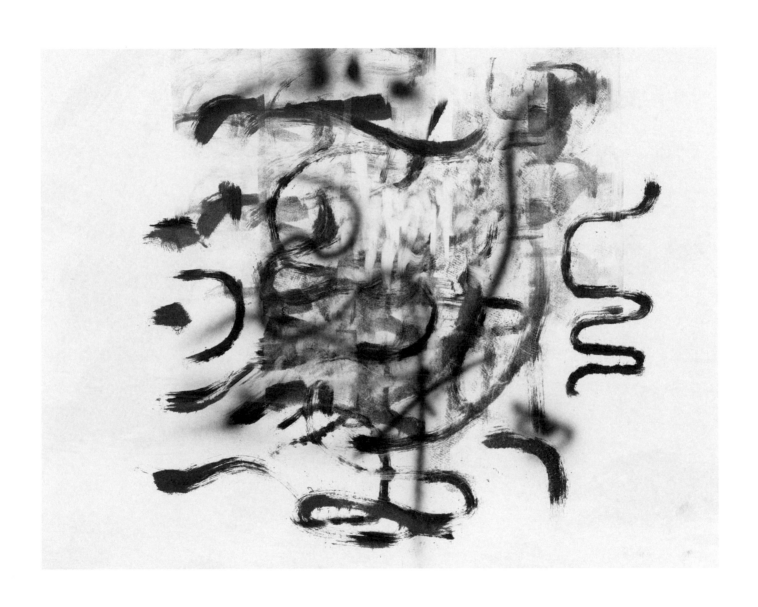

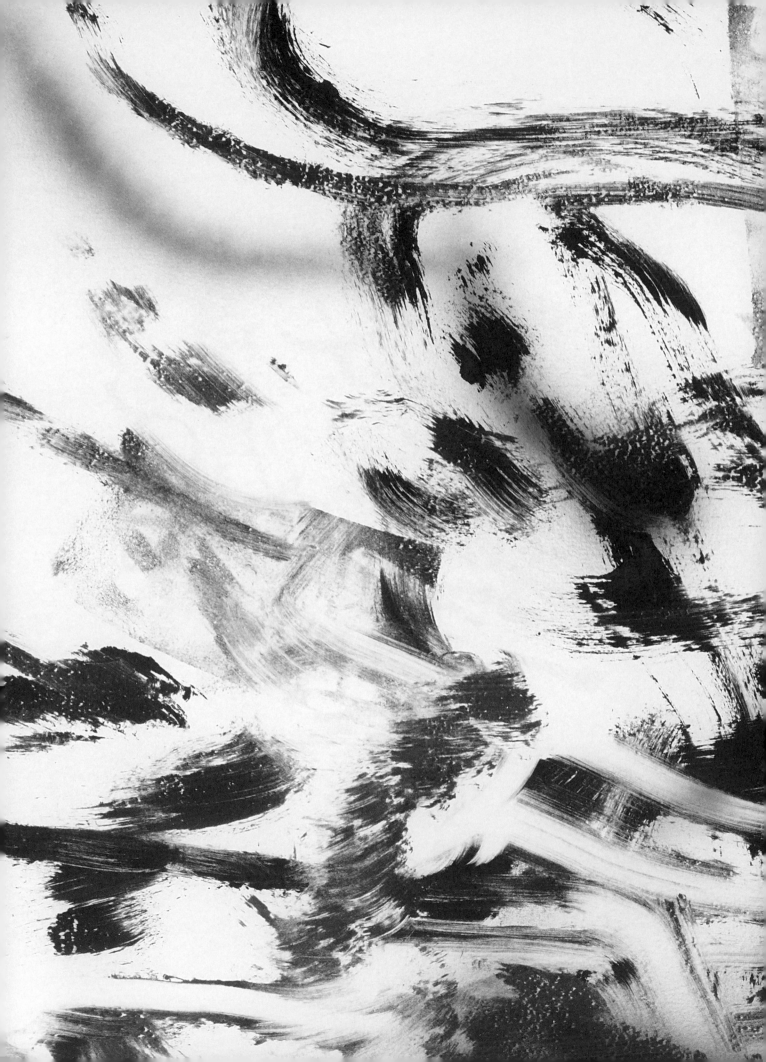

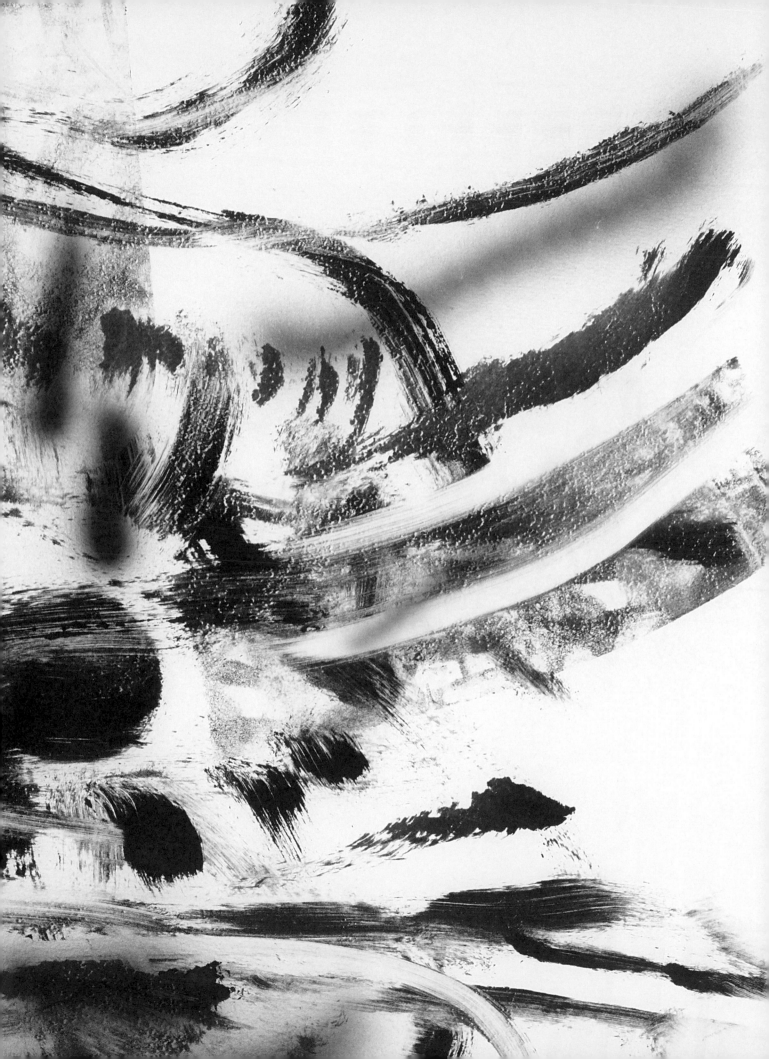

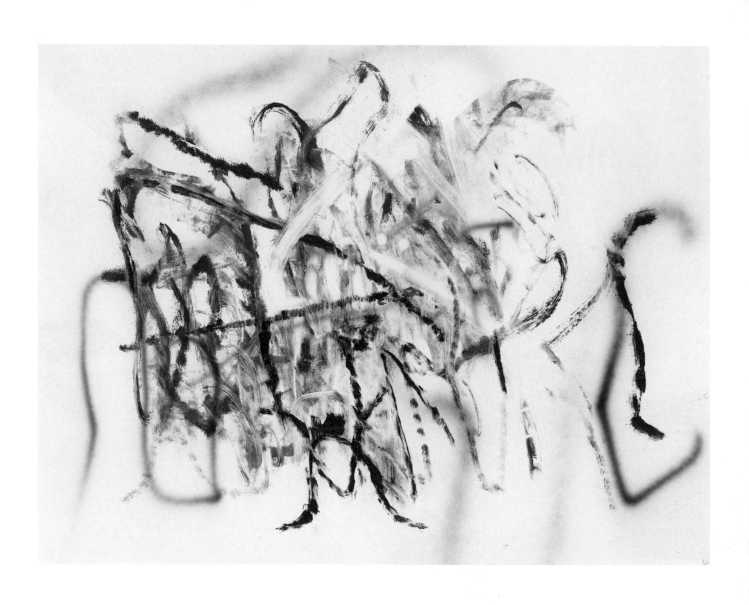

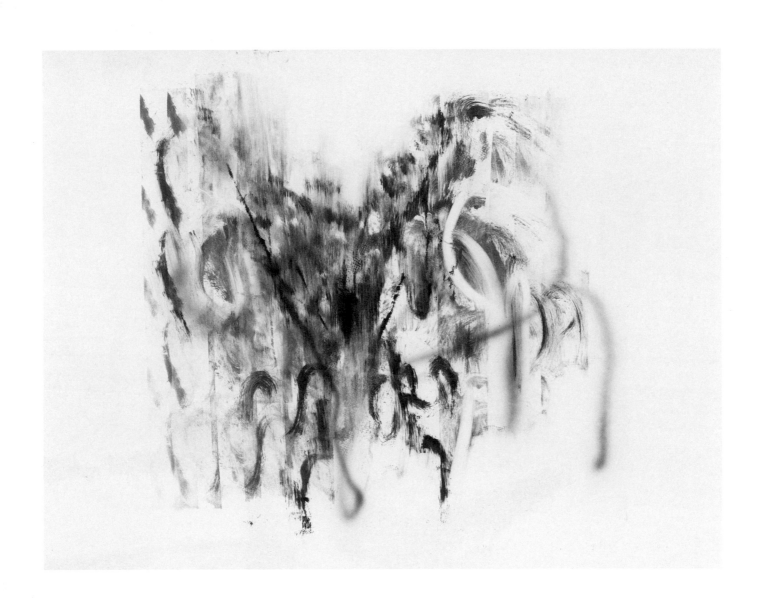

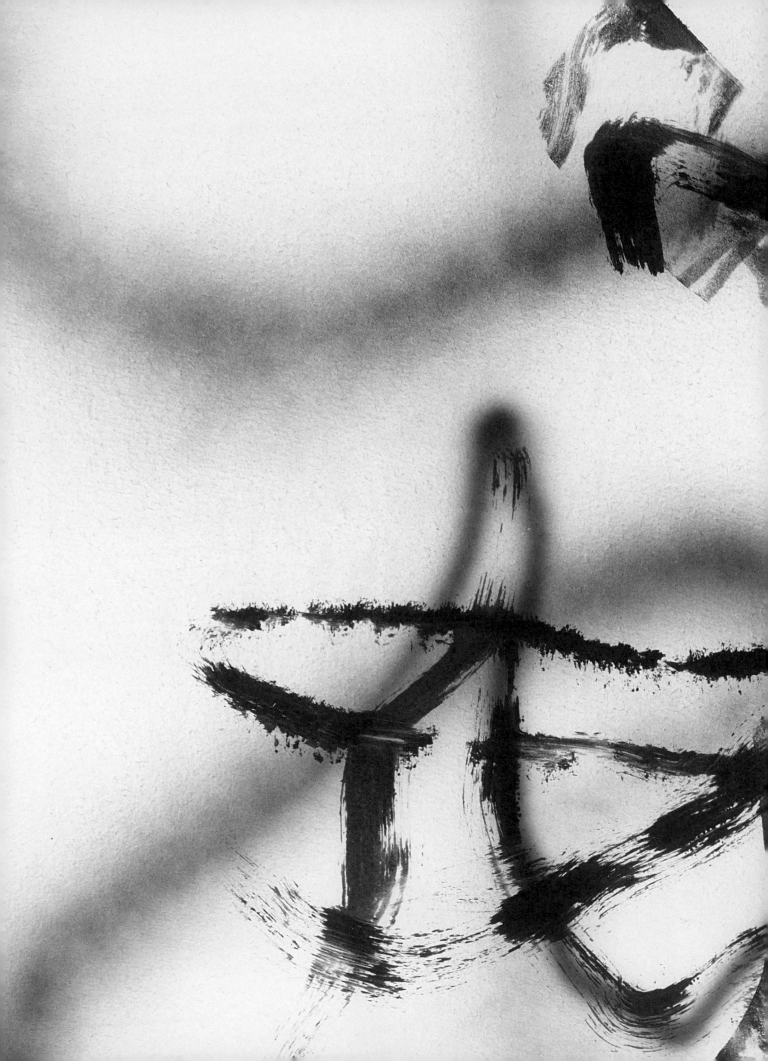

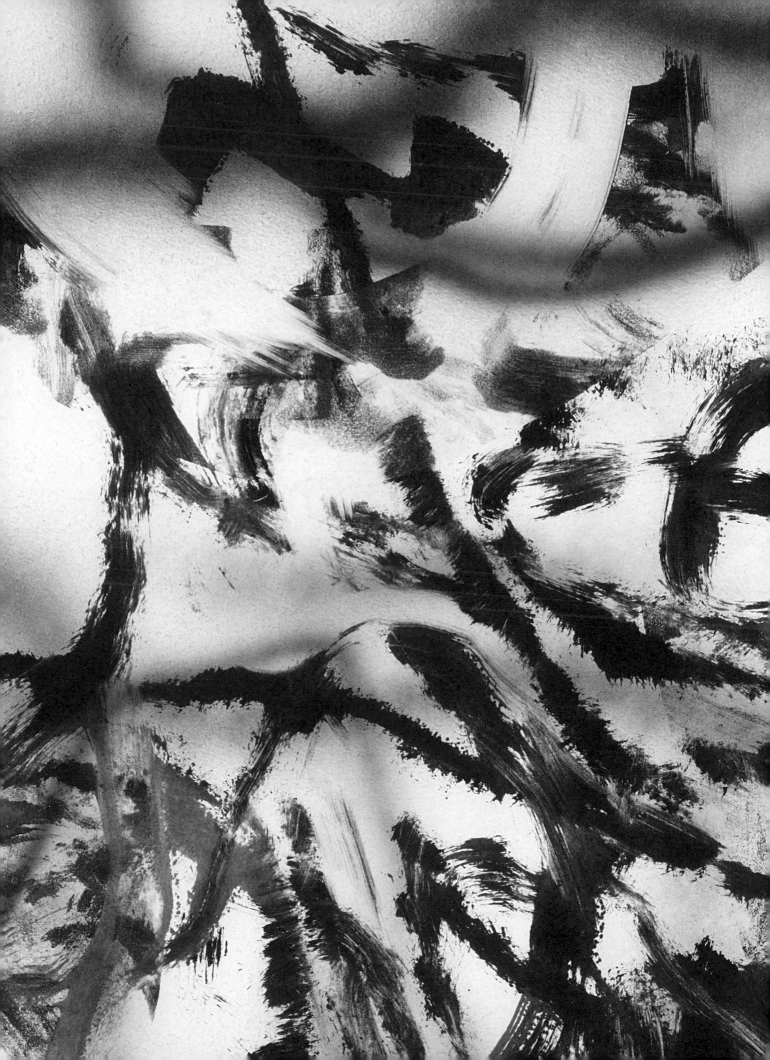

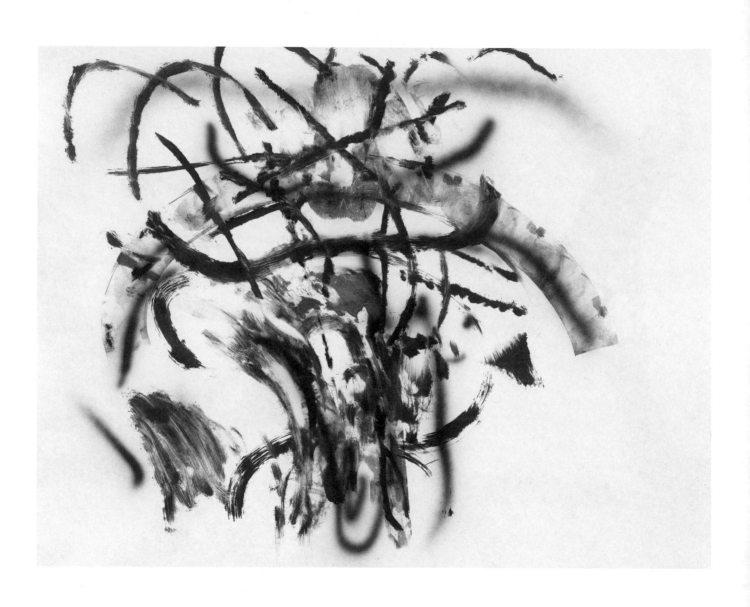

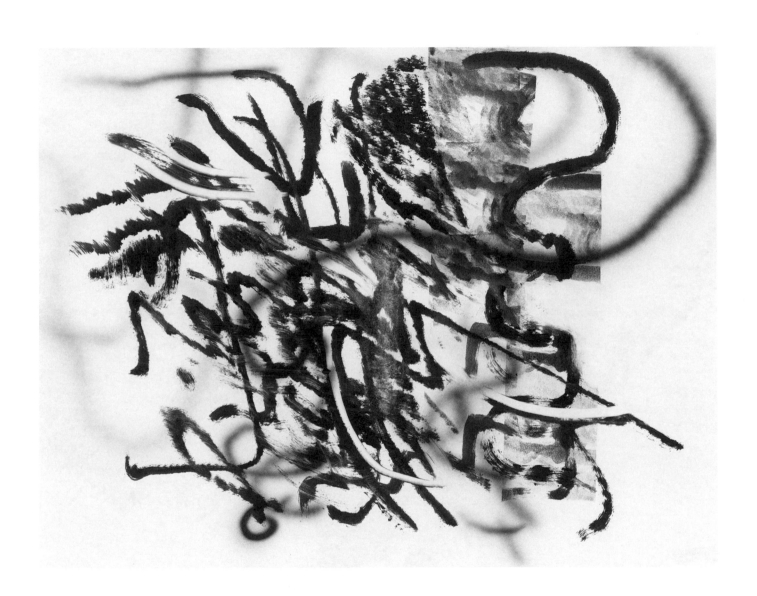

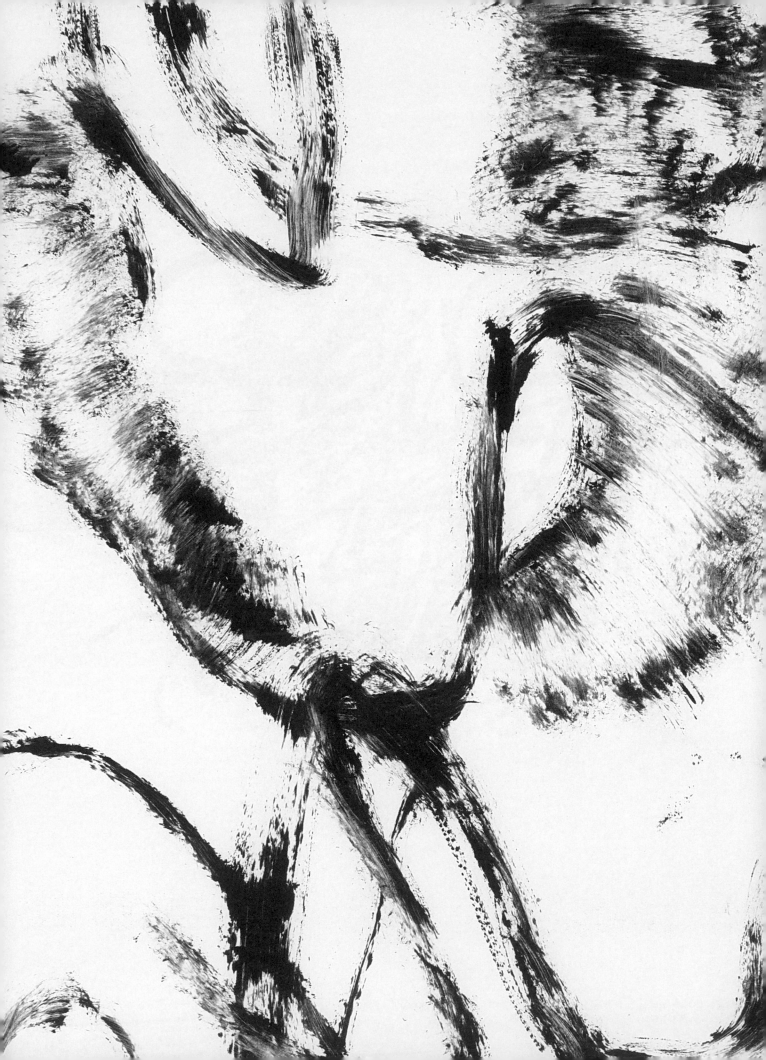

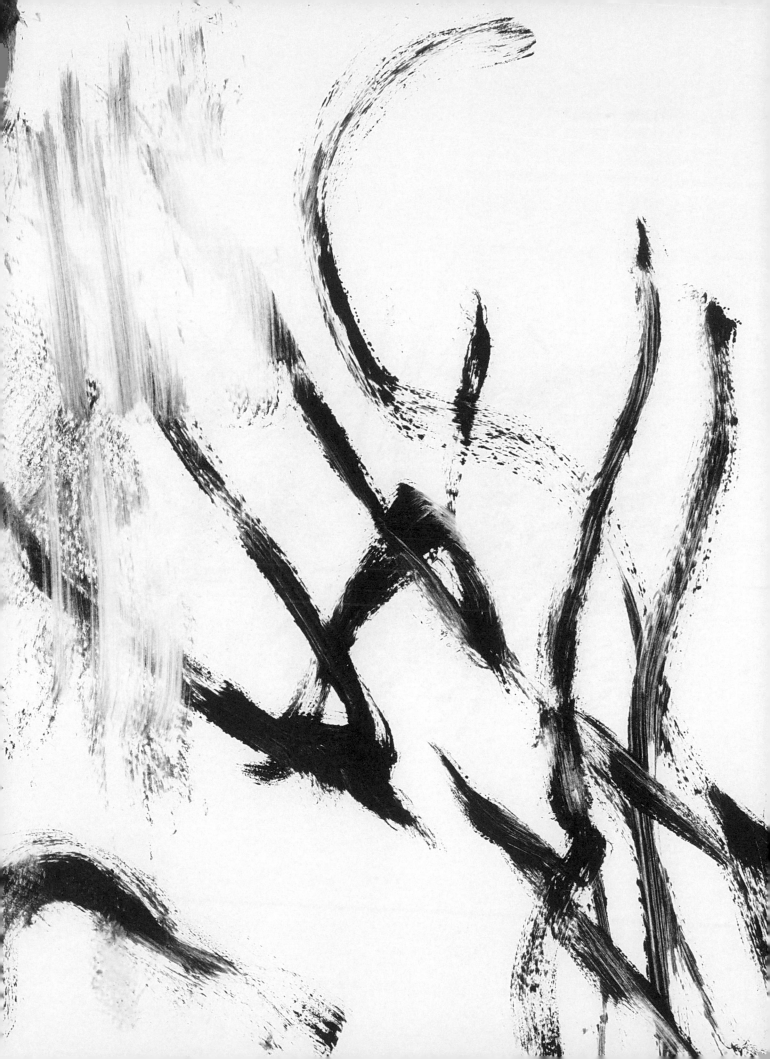

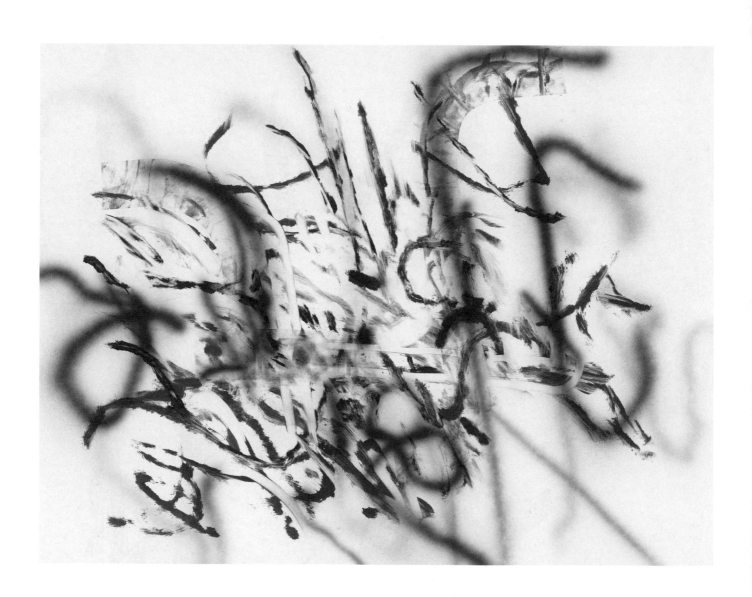

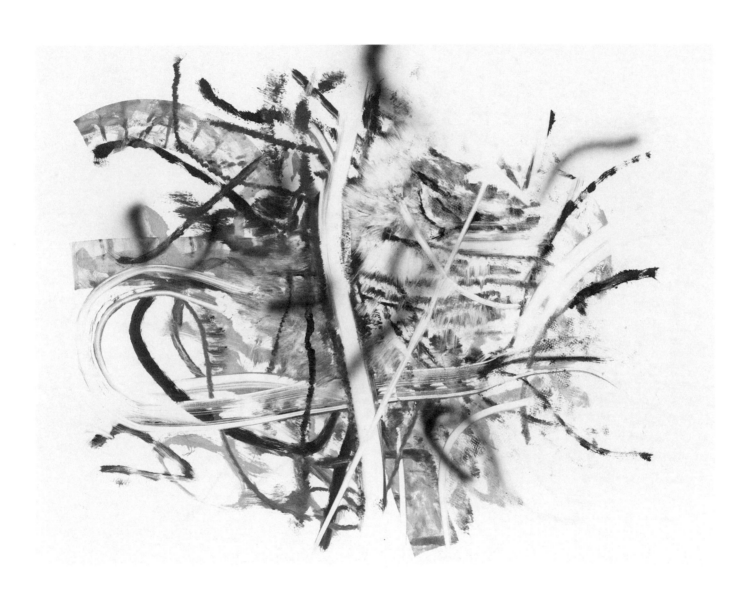

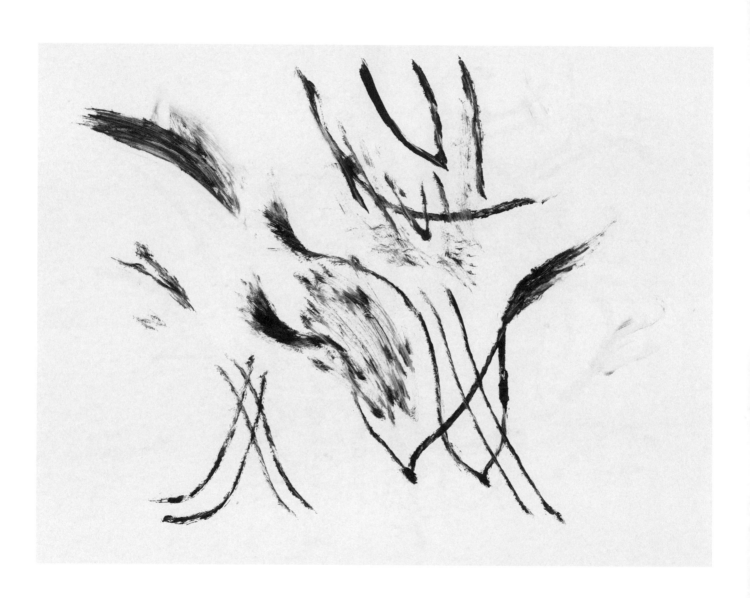

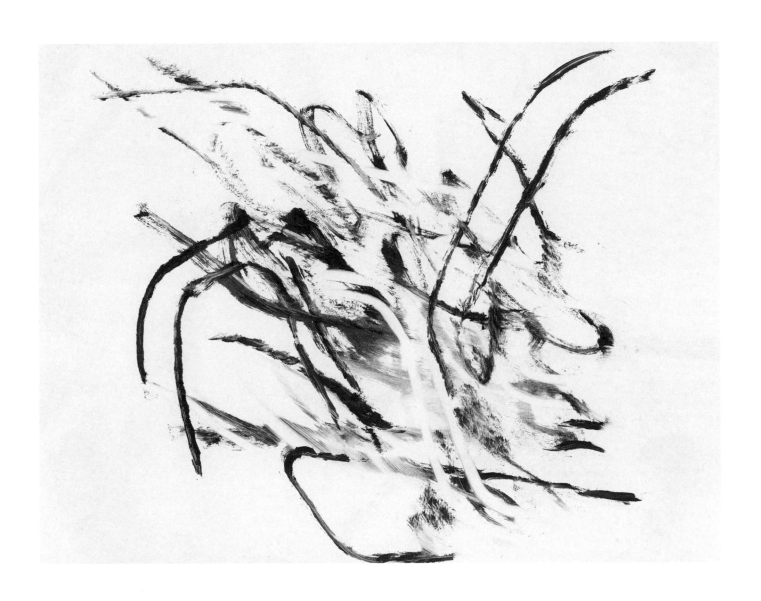

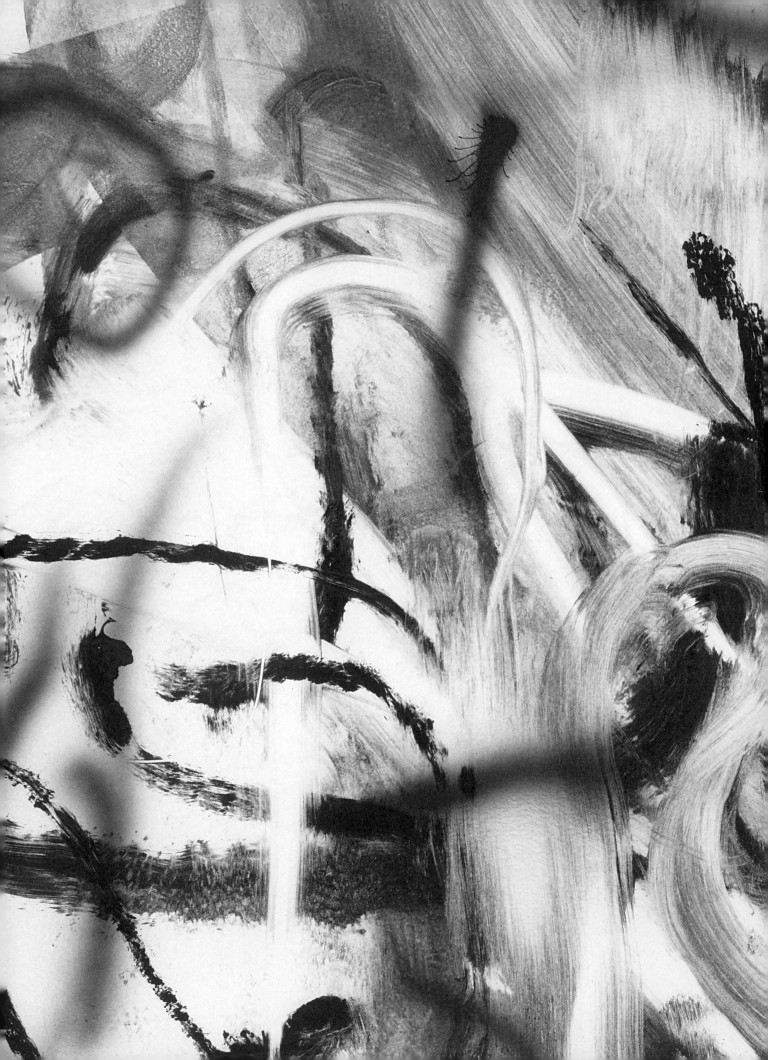

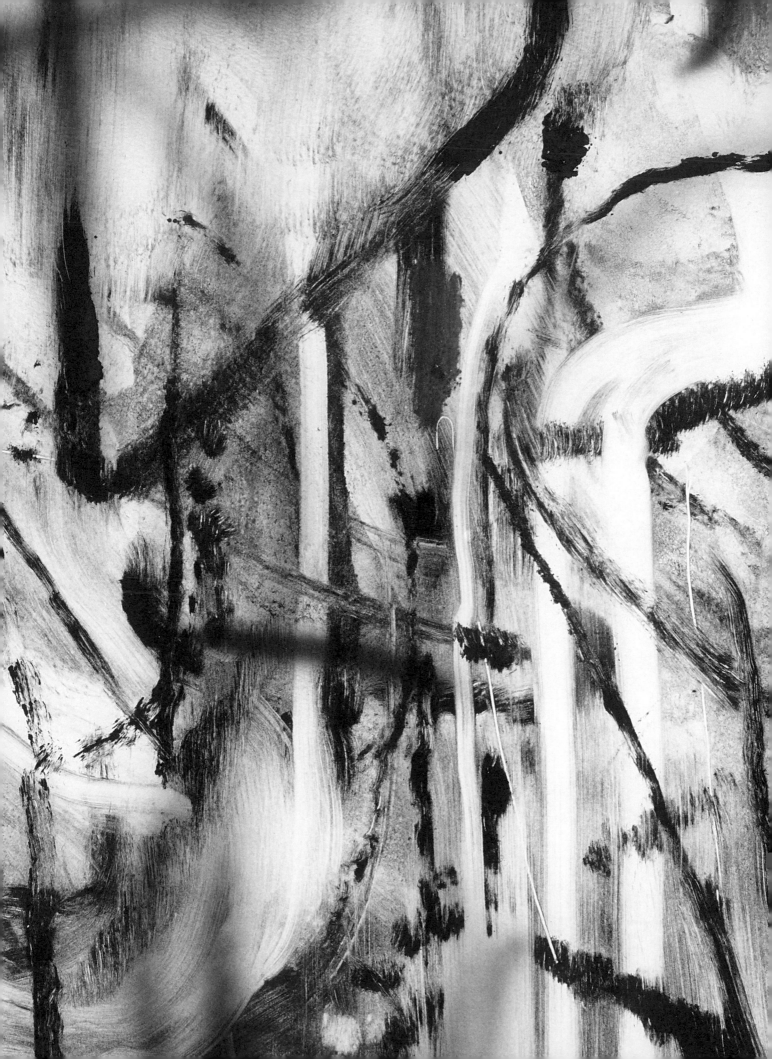

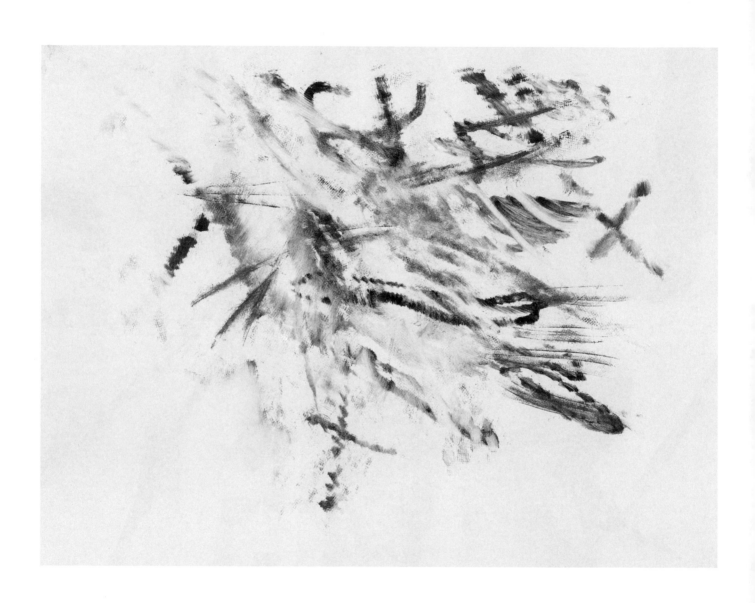

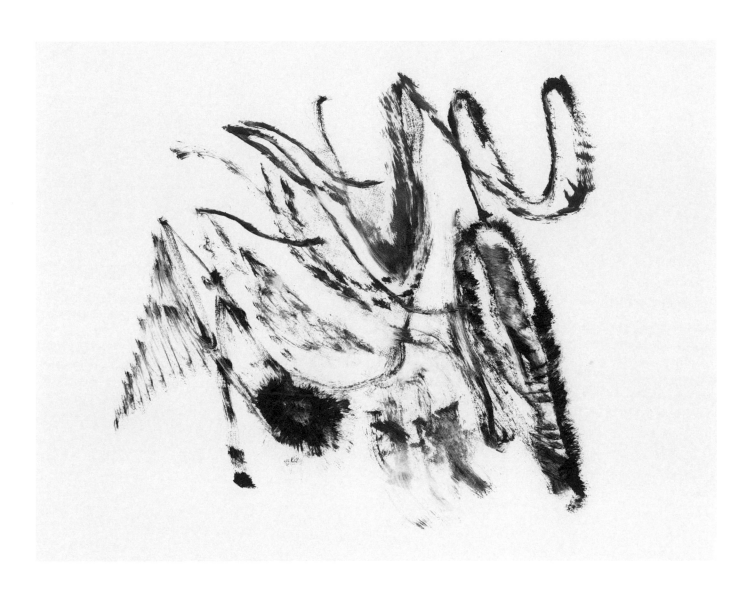

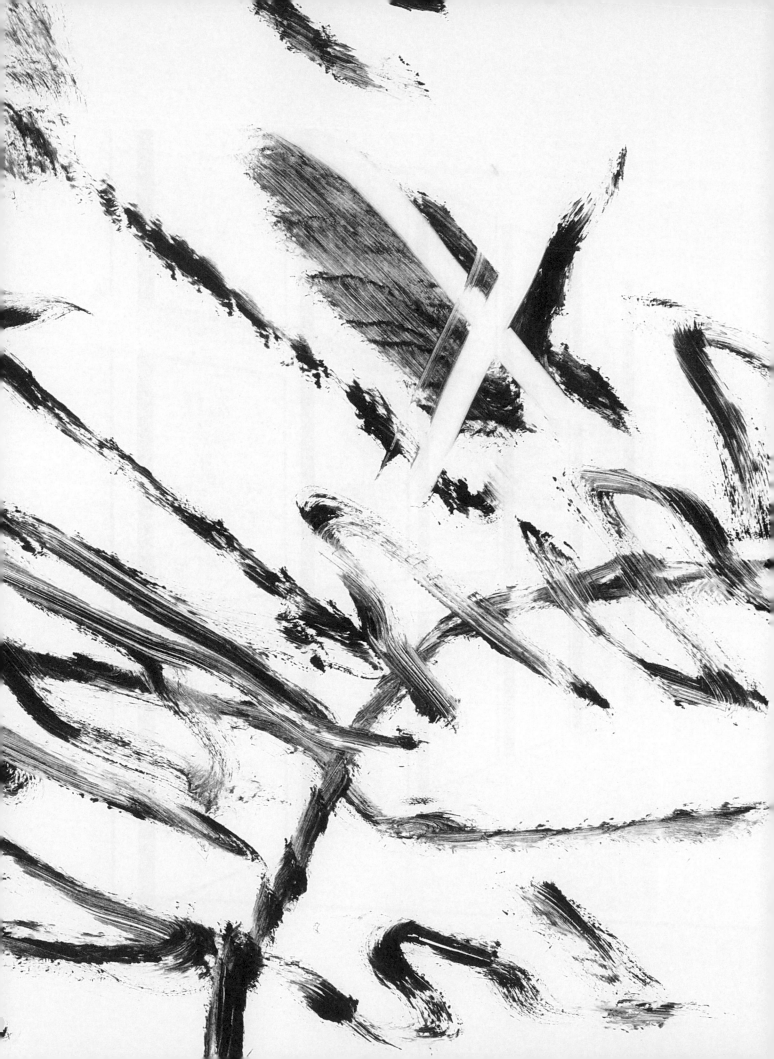

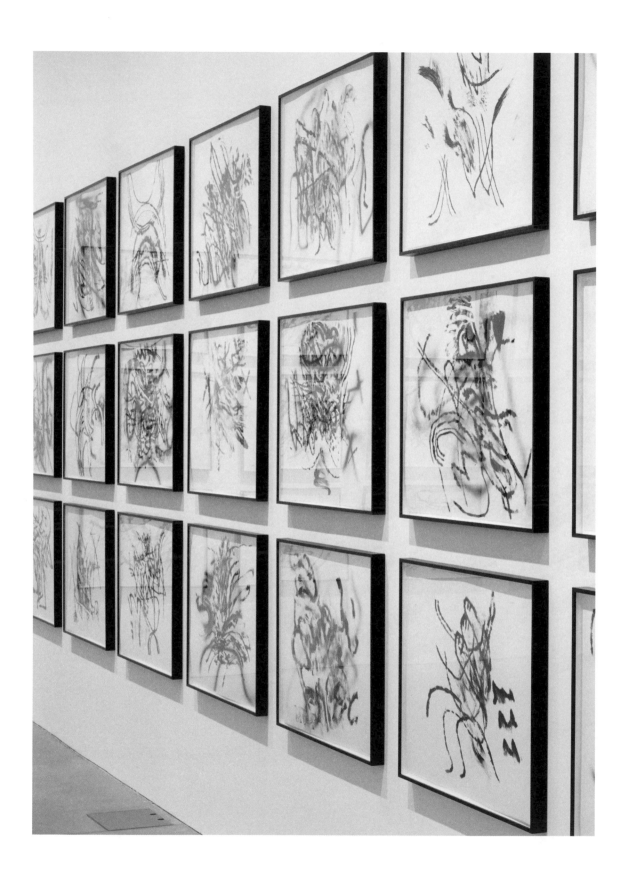

SFUMATO AGAIN

AMY TOBIN

For her exhibition at Kettle's Yard Julie Mehretu has concocted an installation of eighty-four monotypes, titled the *Codex Monotypes*, accompanied by eight drawings. The monotypes take up the entirety of one gallery, stretching across its four walls in an immersive, embracing grid. Like the drawings –which are in two locations, outside the gallery and in the former bedroom of Helen Ede in the Kettle's Yard house – the monotypes are comprised of a lexicon of gestures and forms evident in Mehretu's larger body of work. Plumy lines, dashes, and curves meet arrows and other directional marks. Similar to her other works, these forms are gathered together in configurations; often emerging from a centre point, sometimes gathered as if eddying in a stream of gestural mark-making, sometimes outlining forms. Some sheets even read like maps, or plans with avenues looping across their surfaces. And so, these monotypes and drawings can be connected to what others have described as Mehretu's art of the contemporary cityscape and landscape. Commentators have described how her work is no longer driven by the perspectival, and that she has shown us space as 'a multiplicity of fractured and distorted viewpoints'.[1] Furthermore, by exchanging the singular for the multiple, Mehretu's work has been thought of as a challenge to hegemonic ways of picturing the world, and as a direct response to the enmeshing of the real and the virtual in biopolitical data flows. Her paintings describe migration and surveillance, flight and resistance. Hers, some have argued, is a fugitive perspective, and an art of the undercommons.[2]

At Kettle's Yard the logic of the multiple reigns absolute. Nonetheless this series of works invites a different viewing encounter than the 'environmental experience' of her paintings, which over the last three decades have incorporated existing images, from architectural blueprints to press photographs.[3] They are concerned with bodies, both in representation and eliciting sensation. In this way the monotypes and drawings make a break from the paintings. We might say they are 'in the break', to borrow the poet and theorist Fred Moten's rich and evocative concept.[4] For Moten, to be 'in the break' is to occupy a space of improvisation, away from the centre of things, in which the anarchic and the chaotic takes hold and which leads to new openings, both aesthetic and political. Moten's work describes the imbrication of politics and aesthetics in the black radical tradition, it extends concepts from jazz music to poetry, literature and the visual arts offering a new conception of the avant-garde. To think of Mehretu's work as being in the break, could be to think about a different political-aesthetic experiment in her work. One that suspends the 'painting traversed by history' and instead turns to the history of mark-making and meaning.[5] To be clear, this is not an evacuation of politics, but a flip to a different end of a continuous experiment in abstraction. We could call it, following Moten, an 'immersive lingering' in a space in which fixed meaning is suspended in order for other sensibilities to come into play.[6]

Monotypes, like many other print processes, are associated with the mechanical and the graphic. Print is a medium generally characterised by flatness and impression, rather than depth and expression. As the art historian Jennifer Roberts has suggested print-making has been considered 'subordinate' to painting in the history of modern and contemporary art,

despite artists' experiments with the complex, technical processes of print production to make conceptual leaps in other aspects of their work.[7] Roberts has shown how artists like Jasper Johns and Robert Rauschenberg were indebted to experiments in print-making and with printed matter, disrupting static oppositions between the hand-crafted and the machinic, or flatness and depth. Roberts has also demonstrated the inter-connection between print-making and other kinds of art-making for those artists, suggesting that print has been constitutive for avant-garde art. Mehretu's monotypes should be considered in the light of this revised view. Print-making certainly offered the artist a new set of conditions for image-making. Yet while we could say that these works exist on a continuum with Mehretu's painting, and its use of printed media and digitally rendered marks, I want to hold them apart. Not to suggest that these prints are subordinate to the paintings. But simply to suggest that print is different for Mehretu, and that monotypes in particular, offered a means to investigate a concern common to the paintings, but from a different direction.

The common concern between the monotypes and the paintings is layering. Numerous commentators on Mehretu's work have discussed the stratifications, levels, and coats in her work. These layers relate to three aspects of Mehretu's work: 1) the actual process of making; 2) the metaphoric accretion of signs and referents, and 3) the viewer's excavating gaze. It is the process of making that I am most interested in here. Mehretu's paintings are built up in a number of graphic and painterly deposits and acrylic coatings. Often layers of smooth, clear acrylic separate background from foreground. In the earlier works this meant that swarms of smaller marks sat atop of the structures drawn below, like protagonists occupying a terrain. In more recent works the 'many sedimented strata of pencil, acrylic paint, tape and ink', have become less stratified, the marks less fossilised.[8] Rather, grey-scale paint or highly-pixelated found photographs create a hazy background, upon which plumes of colour and diffused lines effloresce. Visible brush marks are here transformed into impossibly splintered shafts, and feathery tubes. Graphic solidity is exchanged for an amorphous and seemingly gaseous matrix. Strangely there is a shared sense of depth between these earlier and later paintings. The continuity comes from this interest in layering, except in the earlier works the sedimentation is easier to read from the surface of the work than in the later ones.

In the making of her monotypes Mehretu is able to turn her process around. Monotype printing involves drawing onto a smooth metal, glass or plastic panel with ink, before passing the panel and a sheet of paper through a roller, and applying pressure resulting in the transfer of ink from the panel to the paper. Like in her paintings, Mehretu works onto a smooth surface, but here the surface is a piece of transparent Plexiglas. After printing the panel is wiped clean and a new print matrix begun. In this way, monotypes are an idiosyncratic print medium. Unlike etching, woodblock, screenprinting, lithography or aquatint, monotypes are not reproducible, the number of prints is limited to one per completed matrix. The single print, and the smooth surface remove the possibility of Mehretu creating definite layers. A history of marks remains but is now registered across the series, rather than deep into the surface. Instead the illusion of depth develops through the various gestures and marks made. Scratchy brushstrokes that seem to run out of ink appear to recede, while smooth, heavily-inked lines stand their ground. Smudges and smears trace appearances and disappearances, evidencing a literal transit of marks. These transparent and semi-transparent parts read as traces of the artist's actual act of erasing, yet their contingency, frozen in the imprint, is suggestive of their imminent departure, or tentative arrival. Likewise clear paths through deeply inked sections of the panels infer a complete withdrawal, something no longer visible, or absent, or disappeared. Mehretu's removal and smearing of previously drawn lines and marks, is part of the particularity of the monotype process. The smooth, non-absorbent surface allows the artist to erase her marks (and to feather them, extend them and generally change them), while the separation

between the moment of drawing and printing on the surface of the paper creates an interval between making and marking, or another moment of 'immersive lingering' in the break.

Depth is also manifested in the monotypes through overlapping marks, which appear to cross over and intersect in complex knots and jumbles, or which float above graphic crowds. The profusion of different, but repeated marks speak to another kind of layering across the monotypes. Motifs emerge along the rows and columns of the installation, executed with different levels of intensity or in different scales, but still seeming to travel across the works, or through the accumulative process of Mehretu's making. To be sure, these repetitions are not part of a conscious narrative or plan. Rather they are more like a lexicon of gestures that come together to make each sheet different. Some of these marks are specific to this series of prints, some arrive here from other paintings and drawings, some from a longer history of abstract painting that ranges across periods and traditions. When I spoke with Mehretu about this series we described it as an alphabet (actually Mehretu's son's brilliant observation) or a periodic table. Registering the systemic quality of the works, the artist has since titled the works *Codex Monotypes*. Each part, part of something larger, and each part, part of a system of meaning. What it means doesn't matter. It is all jumbled up, and it's up to sensibility and sense to figure something out. But in their relation to sign, language, and system, the monotypes also connect with Mehretu's larger body of work, which has been thought of in relation to the pictogram and the calligraphic gesture.

Despite her interest in the limits of the monotype process, Mehretu trespassed its boundaries to make these works. For instance, she troubled the singularity of the print process with other primitive print-making techniques, including pressing a paper towel onto an inked section to lift the colour in return for the imprint of its regular pattern. Other sheets are marked with bending greyscale columns flecked with marks. These clean-edged, smoothly-applied forms were made with a roller, which had first been passed across an already-worked section, and then wheeled across a clean section where it re-printed the tangle of gestures. These roller prints offer an immediate history of marks made, they allow marks to carry across onto a different panel where they appear like roads or paths across the sheet. Perhaps, Mehretu's greatest challenge to the monotype are the painted marks she adds after the panel is printed. She calls this 'going back into the work'.[9] She does this on many, but not all of the sheets as if to resolve them, or to make them messier. Sometimes these marks are made with a brush, more usually with an airbrush, set to spray at different densities, which Mehretu also controls with her proximity to the surface. The airbrush is one of the ways that Mehretu achieves the strange, airy effect of her more recent paintings, and here too, these marks seem to float on the surface, or even more strangely to recede to the background. As Briony Fer has noted this latter effect produces a confusion over the 'originary mark', so that it becomes impossible to perceive where these works begin and end, when is before and what is after.[10]

Perhaps all this adds up to a sense that Mehretu's abstraction is concerned with illusion, as if the labour of dealing in the lies and distortions of contemporary image culture has evaporated into a mystifying practice. Or perhaps, if we take these works as occupying a Moten-esque 'break', or a Mehretu-esque 'BREAK' then the works come to seem less flippant with social truth, than filled with the possibility that art can achieve new degrees of sensate clarity.[11] In her 'Notes on Painting', Mehretu situates her own interest in the break as a means for making:

> When drawing, pull out of myself, lose place, go deep, into
> pressurised state of disfiguration, disembodiment.
> Lose all sense of cultural self.
> Get lost inside a beat, inside a sonic pulsing system of half links,
> half consciousness, half-wit, find the BREAK.[12]

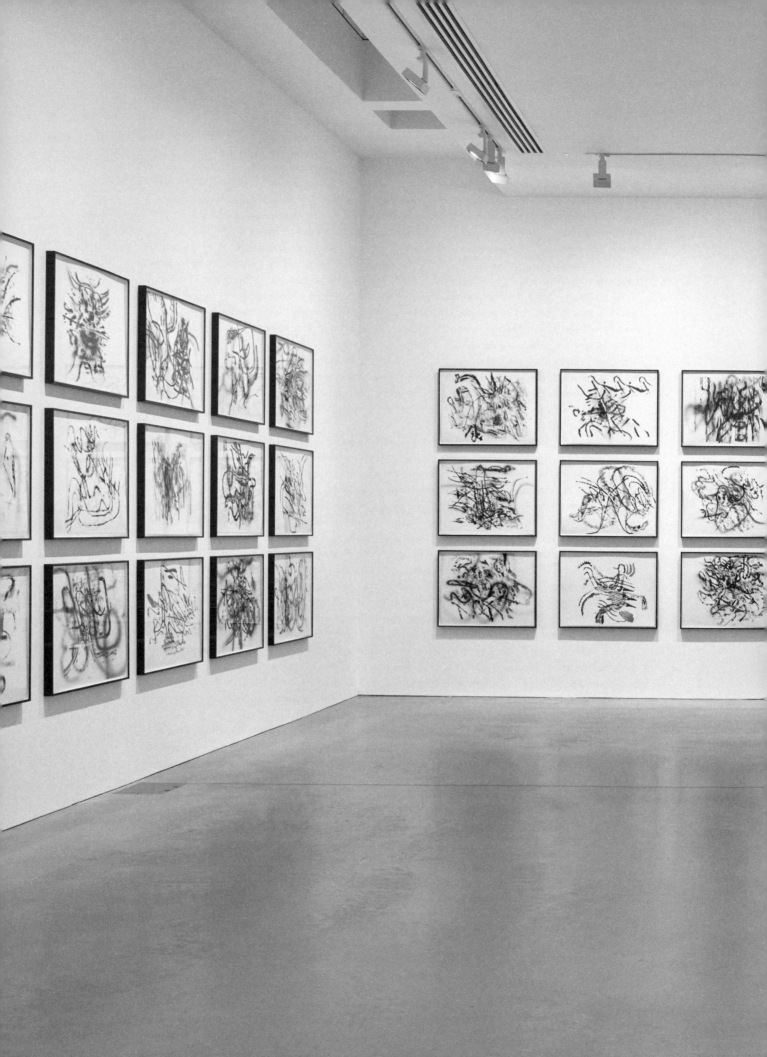

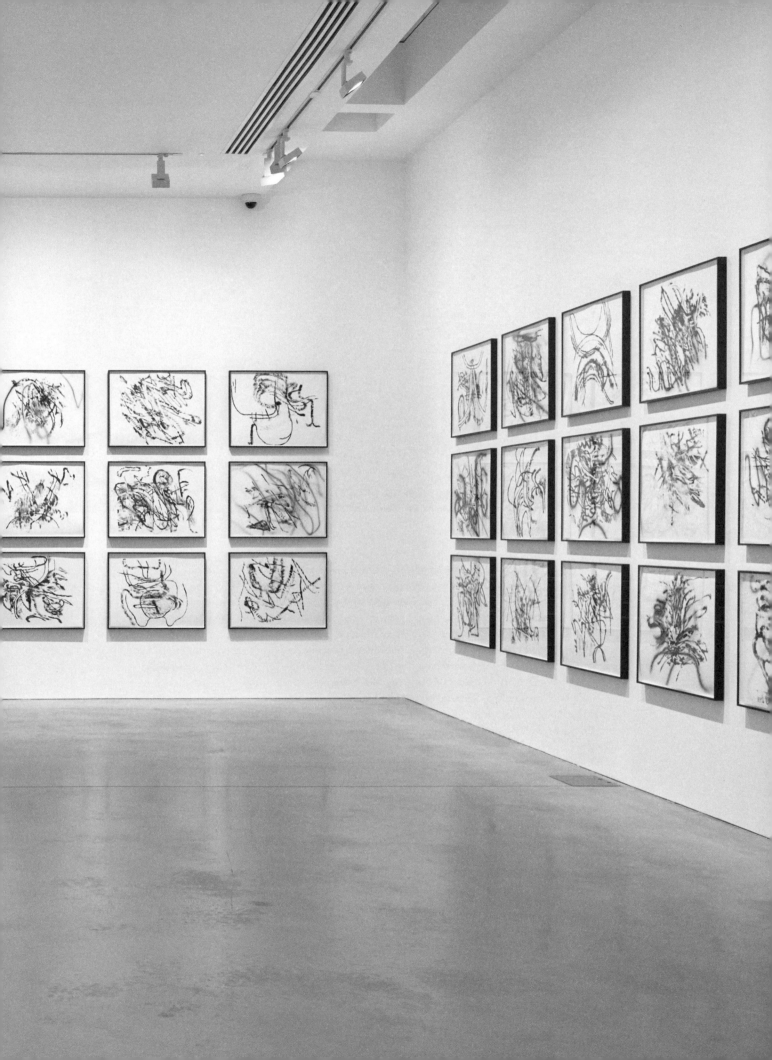

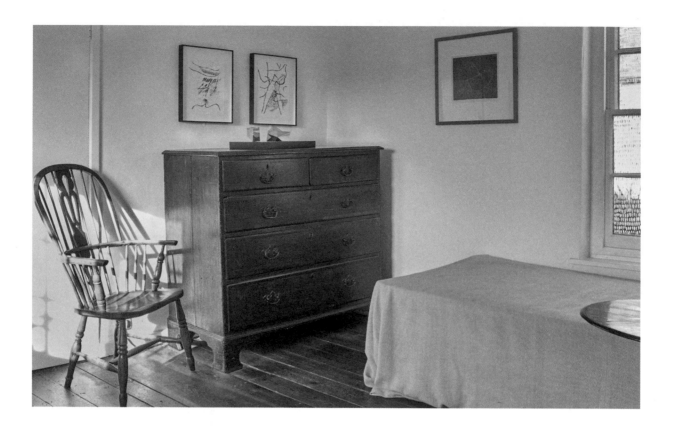

This is a description of making, and making in the break, but this could also be a description of encountering Mehretu's work. Here we leave behind the excavation and start to take it all in, to 'go deep'. In this way we stop trying to prise things apart and start to see the singular in relation to the multiple, or the one connected to the many, like the monotype in the grid. To stop seeing what we know and become 'half-wit'. This experience of seeing close and far away, surface and depth simultaneously and allowing those contradictions to pertain, may indeed tell us something about experience and the sense of being of the world and in the world, of interconnection and responsibility.

This essay is called 'Sfumato again' because when I first saw Mehretu's more recent paintings, and even more so the monotypes, in the flesh sfumato came to mind. Their surfaces are smoky and billowing. They seem to evaporate off the support and condense on the skin. They are haptic in an invasive way. Sfumato is an art historical term that refers to the similarly smoky effect of Renaissance painting, and particularly to the work of Andrea del Verrocchio, and his student Leonardo da Vinci who was thought to have mastered the technique. Art historian Alexander Nagel has described something of the confusion in the usage of the word sfumato.[13] He notes that it is used to refer both to a painterly effect and to the artist's process, as if it is something to produce and the means to produce it. This confusion leads Nagel to the conclusion that Leonardo's perfect execution of sfumato results in the disappearance of the artist's brushwork, and as such the collapse of painting into itself. Nagel says it was the realisation of the 'deepest and original ambitions of the mimetic project'.[14] This return of sfumato might suggest a return to painting as medium. What is groundbreaking for Leonardo is a centuries old problem for Mehretu. Her sfumato effect breaks from Leonardo. Not only

in the different means by which they produce it – remember Mehretu uses an airbrush – but also in their aesthetic projects. The highest aim of a naturalistic art for Leonardo, has been broken and fractured through the technological and virtual environments which form the backdrop for Mehretu's art. But if we can borrow *sfumato* for Mehretu then perhaps we could see more clearly something important in these works. *Sfumato* is so important for Leonardo because its softened edges obliterated the contours that had defined representation in oil painting, that had told the viewer they were looking at an image made to look real. *Sfumato* breaks with this logic of perspectival illusion and instead produces a sensate experience of looking, in which subjects are immersed in their environments, and always in relation. Nagel quoting Leonardo in *The Treatise on Painting* clarifies the point:

> The true outlines of opaque bodies are never seen with sharp precision. This happens because the visual faculty does not occur in paint... [it] is diffused through the pupil of the eye... and so is proven the cause of the blurring of the outlines of shadowed bodies.[15]

Leonardo's opaque and shadowed bodies lend much to thinking about Mehretu's work and her politics of representation. *Sfumato* might offer up an ethical theory of representation in which 'shadowed bodies' escape the harsh light of surveillance and exposure. Perhaps this is the subject of a longer treatise! However, in the context of the works Mehretu has made for Kettle's Yard *sfumato* has another immediate operation, because if you look closely at the abstract marks in the monotypes, bodily forms appear. These range from anthropomorphic shapes interacting – being penetrated or penetrating – to hands with long fingernails that arc across a sheet. Fingers appear in a number of places. These are figures made with outlines and contours, they are not modelled after Leonardo. They point, or seem to jab with manicured nails that threaten to prick or pierce or scratch. Nonetheless these figurative parts blur into their abstract backgrounds, coming forward and moving back, part of their environment, yet always also breaking from it, continuous and discontinuous. In one of the drawings, displayed in Helen's bedroom, one finger appears to be sinking into a Doubting-Thomas style wound half-hidden by other inky scratches. In these smaller drawings – made with ink and paper when Mehretu was away from her studio and staying in her parents' home while thinking about Helen Ede's bedroom – bodies and body parts are much more in evidence. Here bodies without heads spread their legs, and curvaceous buttocks rise out of thickets of abstract inky flicks. In proximity with these probing and penetrating fingers, the drawings are taut with erotic tension, which is differently manifested in clusters of short, hair-like marks, or explosive firework-like bouquets of lines. These more intimate works are another break, another improvisation, this time toward picturing sexual experience.

The drawings and monotypes at Kettle's Yard are experiments with different processes and different conceptual prompts. They are interval works in Mehretu's oeuvre that allow us to think afresh about her experiments in abstraction. The flux of marks and forms make their own system of meaning and description. Sometimes perceptible, sometimes sensible. They tell us of a process of making, and yet confuse that knowing with illusionistic depth. In this way they translate something of the feeling of being a part of and being separate from our surroundings, they create an ethical abstraction that plays with continuity and discontinuity, *sfumato* again for a virtual age.

NOTES

[1] Catherine de Zegher, 'Julie Mehretu's Eruptive Lines of Flight as Ethos of Revolution', *Julie Mehretu: The Drawings*, New York: Rizzoli, 2007, pp. 17-33.

[2] See Macarena Gómez-Barris, 'Julie Mehretu's Undercommons', *e-misférica*, II.2 (2015).

[3] Glenn Ligon, 'On the Ground', *Julie Mehretu: Grey Paintings*. New York: Marian Goodman Gallery, 2017, pp.79-85 and Suzanne Cotter, 'The Alien Discontinuum: On Painting and Participating in the work of Julie Mehretu', *A Universal History of Everything and Nothing*, Porto and Milan: Serralves Museum of Contemporary Art and Mousse, 2017: pp.12–31.

[4] Fred Moten, *In the Break: The Aesthetics of the Black Radical Tradition*, Minneapolis and London: University of Minnesota Press, 2003. Gómez-Barris also connects Mehretu to Moten.

[5] Ligon, 'On the Ground', p.79.

[6] Moten, *In the Break*, p.85.

[7] See Jennifer L. Roberts, *Jasper Johns / In Press: The Crosshatch Works and the Logic of Print*, Cambridge Mass.: Harvard Art Museums, 2012; and 'The Metamorphic Press: Jasper Johns and the Monotype', *Jasper Johns: Catalogue Raisonné of the Monotypes*, edited by Susan Dackerman and Jennifer L. Roberts, New York and New Haven, Conn: Matthew Marks Gallery and Yale University Press, 2017, pp.7–27.

[8] de Zegher, 'Julie Mehretu's Eruptive Lines', p.26.

[9] Julie Mehretu in conversation with the author, 10 December 2018.

[10] Briony Fer in conversation with Julie Mehretu at Kettle's Yard, 21 January 2019.

[11] Julie Mehretu, 'Notes on Painting', *The Medium in the Post-Medium Condition*, edited by Isabelle Graw and Ewa Lajer-Burcharth, Berlin: Sternberg Press, 2016: pp.271–8.

[12] Mehretu, 'Notes on Painting', p. 271.

[13] Alexander Nagel, 'Leonardo and sfumato', *RES: Anthropology and Aesthetics*, no.24 (Autumn, 1993), pp. 7–20.

[14] Nagel, 'Leonardo and sfumato', p.14.

[15] Leonardo's *The Treatise on Painting* quoted in Nagel, 'Leonardo and sfumato', p.9. Nb. The quotation derives from the 1956 McMahon translation.

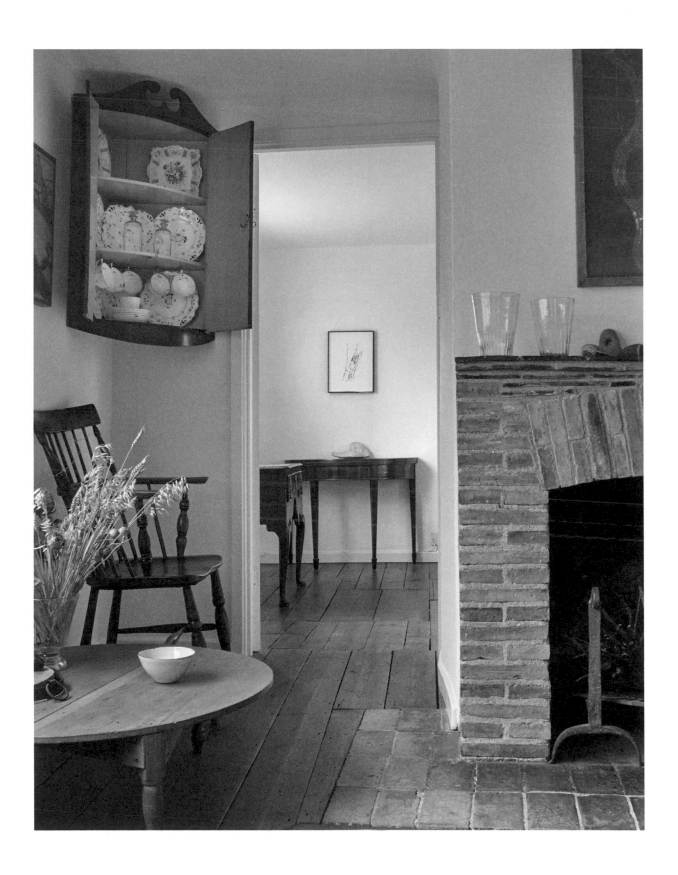

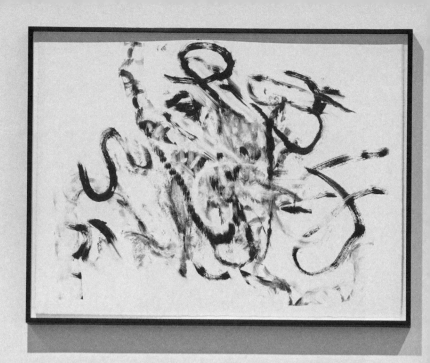
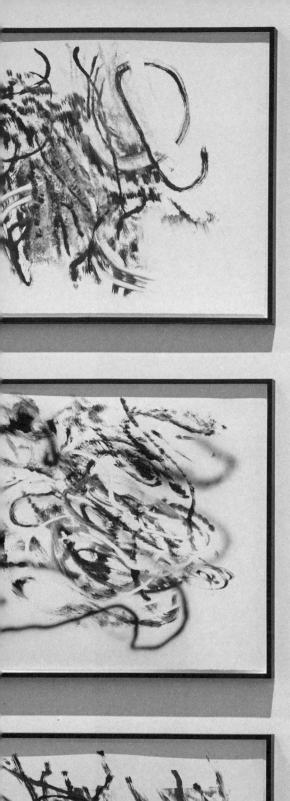
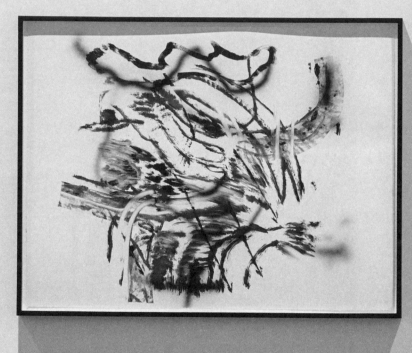
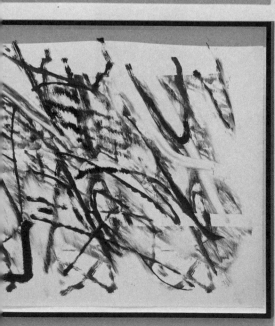
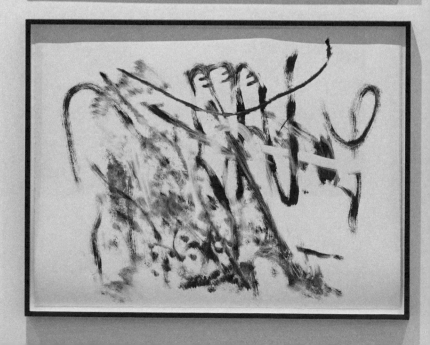

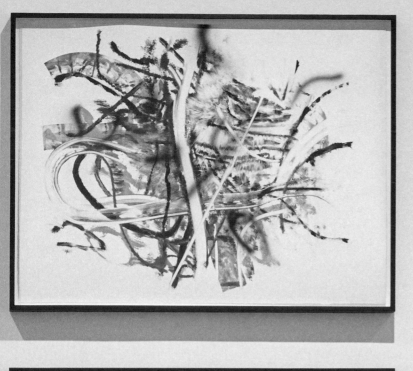
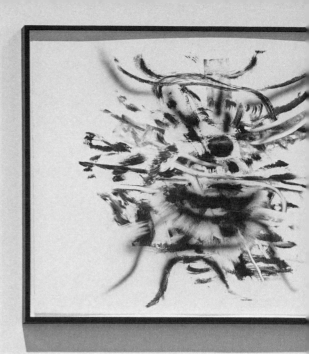
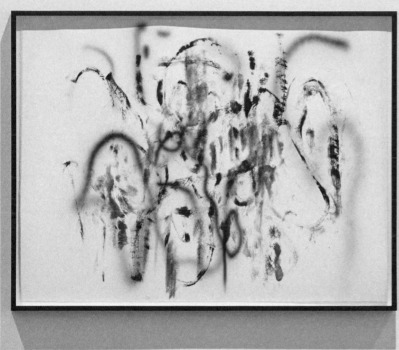
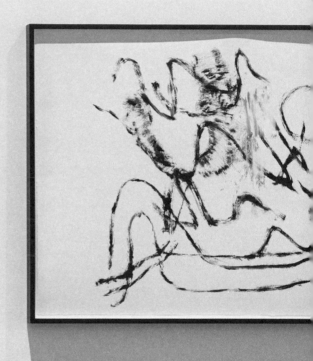
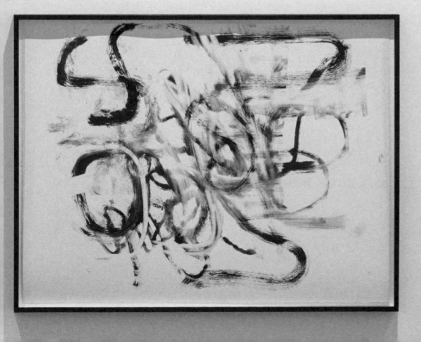
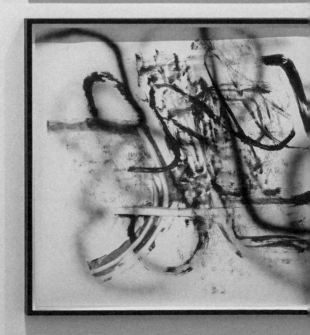

AFTERWORD

ANDREW NAIRNE

Our huge gratitude to Julie Mehretu for creating this remarkable body of work for her first solo museum exhibition in the UK. Kettle's Yard reopened with new galleries and education spaces, designed by Jamie Fobert Architects, in 2018. We were delighted that Julie accepted our specific invitation to exhibit in one gallery, next to an exhibition of work by Louise Bourgeois, curated by Amy Tobin, in the other gallery. Tobin, Curator at Kettle's Yard and Lecturer in the Department of History of Art, University of Cambridge, has also written a new essay about Mehretu's monotypes and drawings for this publication.

The exhibition and this publication has been possible because of the support and dedication of many people. On behalf of Kettle's Yard, I would like to extend my gratitude in particular to Sarah Rentz, Studio Manager for Julie Mehretu, and Susannah Hyman, Associate Director, Head of Exhibitions at White Cube, for their exceptional assistance. Our thanks also to The Bon Ton (Amy Preston and Amélie Bonhomme) for the flair and expertise they have brought to the design of this publication. Finally, my thanks as always to the whole team at Kettle's Yard who in numerous and diverse ways create and produce our programme of exhibitions and events throughout the year.

LIST OF WORKS

Pages 5–15
ALL WORKS
Julie Mehretu
'Drawings for Helen's Room', 2018
Ink on Paper
34 x 24 cm or 24 x 34 cm depending on orientation
Photography: White Cube (Ollie Hammick & Theo Christelis)

Pages 18–19, 22–23, 26–27, 30–31, 32–33, 36–37, 40–41,
42–43, 46–47, 50–51, 54–55, 56–57, 60–61
ALL WORKS
Julie Mehretu
'Codex Monotypes', 2018
Oil based ink and acrylic on paper
55.9 x 73.6 cm
Photography: White Cube (Ollie Hammick & Theo Christelis)

Pages 20–21, 25, 28–29, 35, 39, 44–45, 48–49, 52–53, 58–59, 63
ALL WORKS
Julie Mehretu
Detail from 'Codex Monotypes', 2018
Oil based ink and acrylic on paper
55.9 x 73.6 cm
Photography: White Cube (Ollie Hammick & Theo Christelis)

Pages 64, 68–69, 70, 73, 74–75
ALL IMAGES
Installation view 'Julie Mehretu: Drawings and Monotypes'
Photography: Stephen White

ACKNOWLEDGEMENTS

Julie Mehretu would like to thank:
Andrew Nairne, Amy Tobin, Greg Burnet, Sarah Madden, Briony Fer, Amy Preston,
Amélie Bonhomme, Eliza Spindel, Susie Biller, Guy Haywood, Jennifer Powell, Jay Jopling,
Susannah Hyman, Susanna Greeves, Bea Bradley, Marian Goodman, Emily-Jane Kirwan,
Frank Müller, Emmanuel Post, Tacita Dean, Mathew Hale, Sarah Rentz, Clara Ranenfir,
Damien Young, Jessica Rankin, Cade Mehretu-Rankin and Haile Mehretu-Rankin.

We are grateful to the following for their generous support:

WHITE CUBE

Director's Circle:
Dr Carol Atack and Alex van Someren, Sir Charles and Lady Chadwyck-Healey,
Robert Devereux, Guy Vesey, and those who wish to remain anonymous

Ede Circle members:
Hilary Aldred, Marjolein Wytzes and Michael Allen OBE, Stuart Ansell, Roger Bamber,
Clodagh and Jonathan Barker, Lady Madeleine Bessborough, Dr Helaine Blumenfeld OBE,
Dr Sophie Bowness, Adrian and Leanne Clark, Dr David and Rosalind Cleevely, Eve Corder,
John and Jennifer Crompton, Professor Martin and Dr Claire Daunton, Lucy Davison,
Sally and Michael Fowler, James Freedman and Anna Kissin, Peter Gerrard, Nick Gomer,
Dr Sean Gorvy, Jane Jackson, Peter Klimt, Dr Claudio Köser, Tim Llewellyn, Robin Light,
Nicki Marrian, Suling Mead, Professor Keith Moffat, Ken and Annabel Neale, Jonathan and
Nicole Scott, Stuart Shave, Alan Swerdlow and Jeremy Greenwood, Reverend Peter Wolton,
Jenny Little, Toby Smeeton, Dr MaryAnne Stevens, Louisa Riley-Smith, Professor
Elizabeth Simpson, Rosanna Wilson Stephens and those who wish to remain anonymous

Honorary Ede Circle members:
Anne Lonsdale CBE and Lord Richard Wilson of Dinton

JULIE MEHRETU: DRAWINGS AND MONOTYPES

Published by Kettle's Yard, University of Cambridge, 2019

Edited by Andrew Nairne and Amy Tobin
Assisted by Eliza Spindel

Design by The Bon Ton
Printed and bound by Xtraprint
Edition of 1500 copies

ISBN 978-1-904561-92-7

Exhibition curated by Andrew Nairne
Assisted by Guy Haywood, Jennifer Powell and Amy Tobin

Kettle's Yard, Castle Street, Cambridge CB3 OAQ, United Kingdom
+44 (0)1223 748 100 kettlesyard.co.uk
Director: Andrew Nairne Chair: Dr Rowan Williams

SUPPORT

Kettle's Yard relies on the generosity of supporters to care for the collection
and historic buildings, and enable us to offer a full programme of activities,
from exhibitions, learning activities and music to publications and research.
All gifts, large and small, help to safeguard the collection for future
generations, and enable others to enjoy Kettle's Yard now and in the future.

There are a variety of ways in which you can help support Kettle's Yard and
also benefit as a UK or US taxpayer. For more information please visit
kettlesyard.co.uk/supporters

Inside back cover: Julie Mehretu's hand

KETTLE'S YARD